Ghost Signs of Arkansas

Ghost Signs of Arkansas

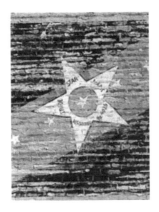

Written by Cynthia Lea Haas
Photographs by Jeff Holder

The University of Arkansas Press
Fayetteville ⁓ 1997

ISBN: 978-1-55728-480-8
eISBN: 978-1-61075-169-8

25 24 23 22 21 5 4 3 2

Designed by Liz Lester

⊜ The paper used in this publication meets the minimum requirements of the American
National Standard for Permanence of Paper for Printed Library Materials Z39.48-1984.

Library of Congress Cataloging-in-Publication Data

Haas, Cynthia Lea, 1952–
 Ghost signs of Arkansas / written by Cynthia Lea Haas ; photographs by
Jeff Holder.
 p. cm.
 ISBN 1-55728-480-6 (alk. paper)
 1. Brick wall signs—Arkansas—History. 2. Advertising—Arkansas—
History. 3. Street art—Arkansas—History. 4. Brick wall signs—Arkansas—
Pictorial works. 5. Advertising—Arkansas—Pictorial works.
 I. Holder, Jeff, 1950– . II. Title.
 HF5841.H35 1997
 659.13'42—dc21 97-16653
 CIP

*Funding for this book is from the Arkansas Historic Preservation Program, an agency of the Department of
Arkansas Heritage.*

Frontispiece photograph:

A building burned a few years ago in Hot Springs
(Garland County) and exposed this early cigar
sign, which, thanks to their locally ordinanced
historic district, was allowed to retain its
original form. *1990*

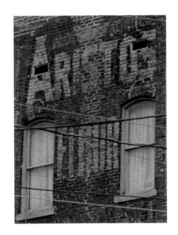

To all the skilled craftsmen and artists known as sign painters whose work is found throughout Arkansas.

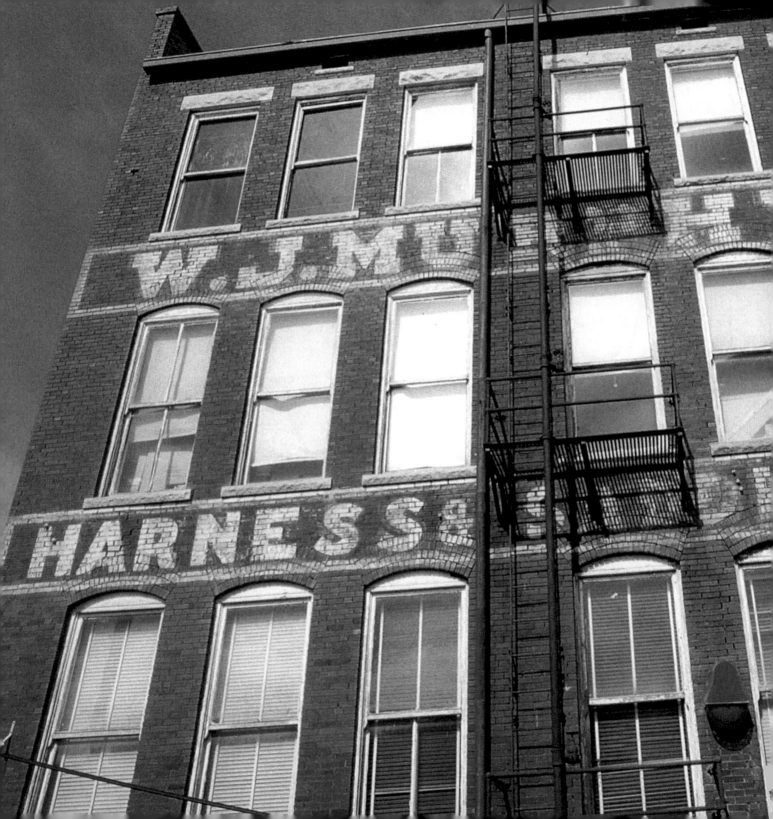

Acknowledgments

Gratitude is due to the following people whose assistance, contributions, and support helped to make this book a reality:

Cathy Slater, director, Arkansas Historic Preservation Program

Ken Grunewald, deputy director, Arkansas Historic Preservation Program

Mark Christ, special projects coordinator, Arkansas Historic Preservation Program

Nancy Lowe, architectural design consultant, Main Street Arkansas

Marian Boyd, state coordinator, Main Street Arkansas

Sandra Hanson, Little Rock, Arkansas

Bill Puppione, Memphis, Tennessee

Allan Abbott, Little Rock, Arkansas

Gloria Greer, Smackover, Arkansas

Kerry and Jerry Kemp, Little Rock, Arkansas

Malinda Herr-Chambliss, Hot Springs, Arkansas

Don Lambert, director, Oil and Brine Museum, Smackover, Arkansas

Bonnye Maxwell, McGehee, Arkansas

John B. Talpas, El Dorado, Arkansas

Kay Danielson, Jacksonville, Arkansas

Elaine Black, Benton, Arkansas

Betsy McGuire, Main Street Russellville, Arkansas

Dave Timko, Main Street Batesville, Arkansas

Jay P. Beard, Paragould, Arkansas

Max Brantley, Little Rock, Arkansas

W. J. Murphy Harness and Saddlery in Fort Smith (Sebastian County). *1991*

Bob Davis, Pine Bluff, Arkansas

Bill Thomas, Conway, Arkansas

Michael J. Auer, National Park Service, Washington, D.C.

Dr. Frank Schambach, Arkansas Archeological Survey,
SAU, Magnolia, Arkansas

Dr. Leslie Stewart-Abernathy, Arkansas Archeological
Survey, ATU, Russellville, Arkansas

Robert "Bob" Adair, Pine Bluff, Arkansas

Hank Berry, Jonesboro, Arkansas

A. J. Anderson, Little Rock, Arkansas

Lynn White, Jackson, Mississippi

Also, we would like to express our thanks to the following
staff of the Old State House Museum: Bill Gatewood, curator;
Steve Gable, exhibits specialist; and Larry Ahart, historian, for
their creation of a photographic exhibit about these signs which
helped to set the stage for this book. The exhibit was funded in
part by a grant from the Winthrop Rockefeller Foundation.

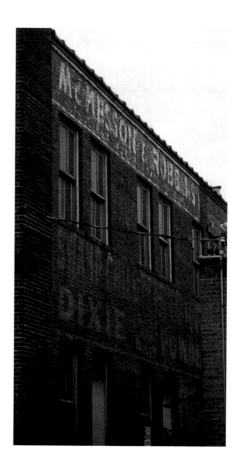

What was "swamp chill"? Whatever it
was, Dixie Powder was the cure.
Fort Smith (Sebastian County). *1990*

Contents

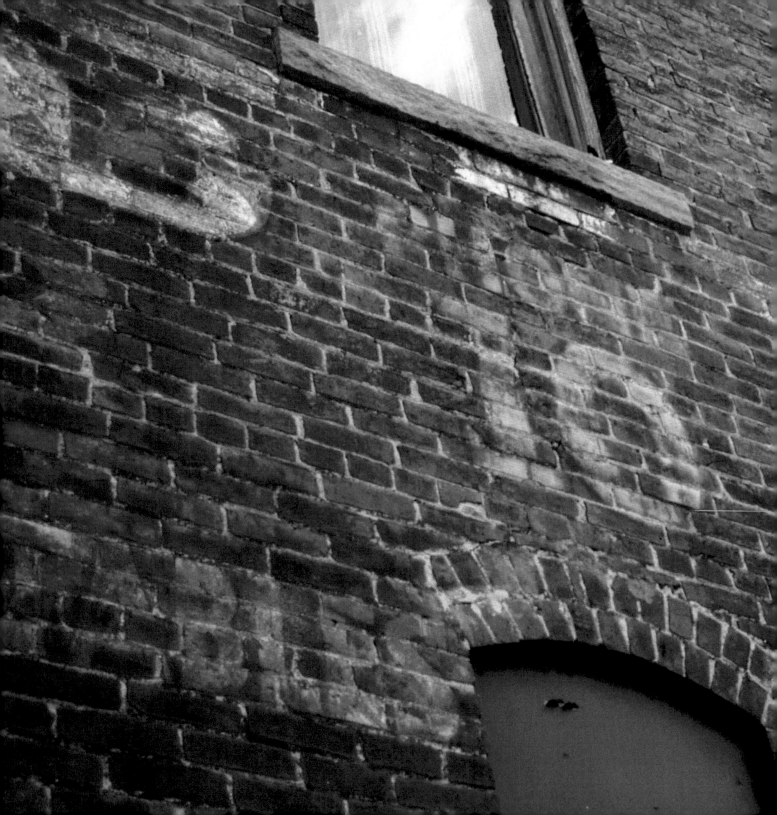

Foreword

I celebrate the work of Cynthia Haas and Jeff Holder in documenting the "ghost signs" that survive in Arkansas. Ghost signs remind us of the local scale of place. These signs are evocative of small towns past, of occupations long gone, of families and businesses once successful and vital but now hardly remembered.

Who needs a time machine when, by looking at those signs, we can "short circuit" the past, to use Kevin Lynch's phrase (page 59 in *What Time Is This Place* [MIT Press, Cambridge, Mass., 1972]). We drive down Main Street, glance up and see a faded sign on the side of an old brick building, and suddenly we are back in a time when the local experience was the most meaningful. It's no longer 1996 but 1886, or 1926, when the product and the company and the family being celebrated by that sign were a vital part of the neighborhood and community. And the world was not yet torn apart by unimaginable conflicts, nor linked too closely by multinational corporations and television. And then when we must pull our eyes back to the road and the traffic and the present, we are a little different.

As an Arkansawyer, I have my own memories from the 1950s of ghost signs. I saw them in my hometown of Jonesboro and in the small towns in the Delta such as Bay and Portia and Marked Tree that my family drove through on the way to visit relatives in Memphis. The Delta and my hometown were undergoing tremendous changes, but the ghost signs clearly recorded other ways and other days. The names and addresses of Chinese-American laundries were still being proclaimed but the

Phone 10 recalls the number to a bygone business on the side of a commercial building in Siloam Springs (Benton County). *1992*

businesses themselves were no more. The "hobble skirt" Coca Cola bottles painted ten feet high on the sides of country stores were already antique, as were the independent country stores themselves.

As historical archeologist for the state for the past nineteen years, I have gained an appreciation as well for the fragility of the ghost signs across the entire state. These signs, as with archeological sites, contain a tremendous amount of news about past life, but they are vulnerable to damage and loss. The ghost signs are now disappearing even more rapidly than the laundries and the stores, thanks to ordinary actions such as repainting a wall or demolishing an "unsafe" building.

Without vigorous efforts to document these signs, and then to remind people about their significance, the ghost signs will have all vanished, and with them the intimate ties to place and time. The only signs left will be those of the national retailing chains and gas stations, and the ties to the "local" will be further broken. We won't have much idea of who we are, because we will have forgotten where we and our townscapes have come from. Ghost signs are one element in our daily life that point to other paths to travel. This book will help us remember them.

—Leslie C. Stewart-Abernathy

An early coke sign still dominates the wall of a by-gone cafe along the railroad tracks in El Dorado (Union County). *1992*

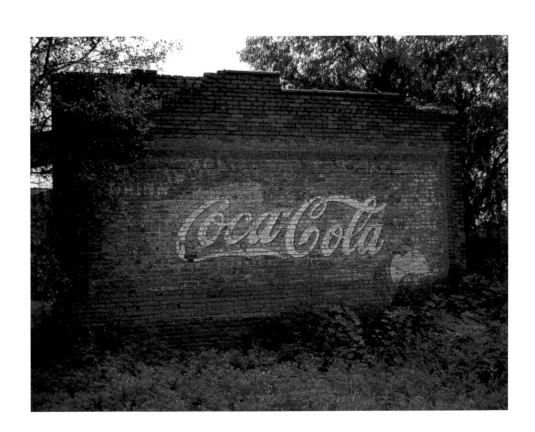

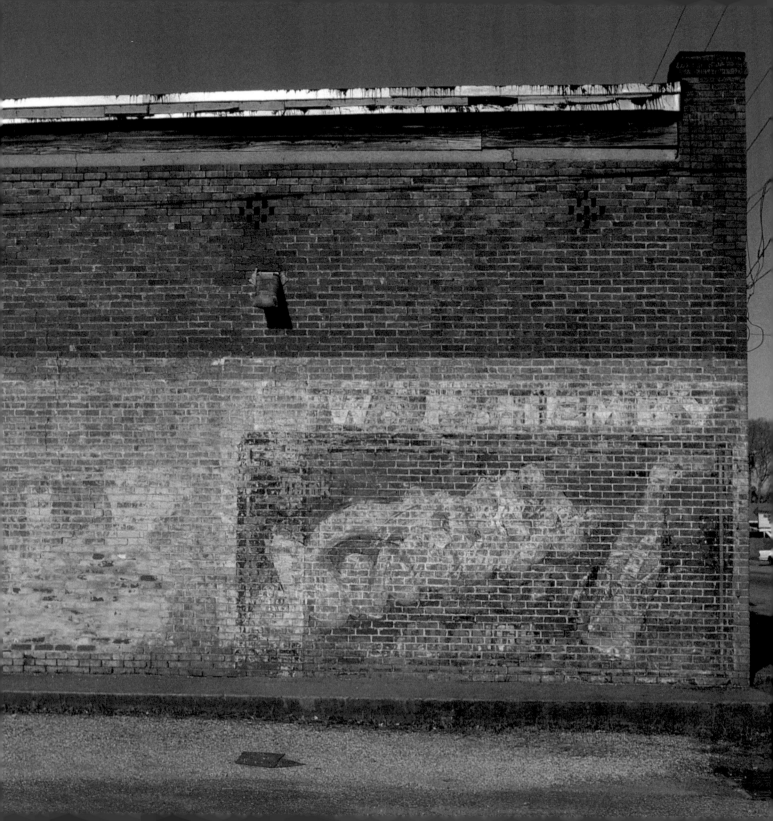

INTRODUCTION

THERE are a vast number of faded wall signs or "ghost signs" that are tucked away on the front, sides, and backs of buildings that fill the downtowns or punctuate the surrounding landscape of Arkansas. Ghost signs are a part of our past as they are remnants of the culture and daily life of a by-gone era. These painted wall signs are artifacts that cannot be easily placed in museums or bought for private collections. Each fading sign has a story that contributes to the collective memory of the people, products, and events that influenced common interests and shaped the destiny of small-town America.

What are ghost signs? In a time before the emergence of mass media, sign painters practiced their artistry on exposed wall surfaces that provided the backdrops, thereby enabling companies to get their products and wares before the public. Now, years later, these faded messages haunt upper-level corners, entire sidewalls, and even narrow alleyways as a testament to the time when craftsmanship and practicality were combined in a traditional graphic art form that has all but disappeared in today's society. As valuable historic resources, they continually change, and sometimes perish, due to deterioration from neglect or the elements or from alterations that occur as buildings evolve to meet contemporary needs.

This sign, painted in 1947, names a Mr. W. P. Hemby, who was a local pharmacist in Delight (Pike County).
1992

Note: Unless otherwise noted in the text, the date the photo was taken follows the caption.

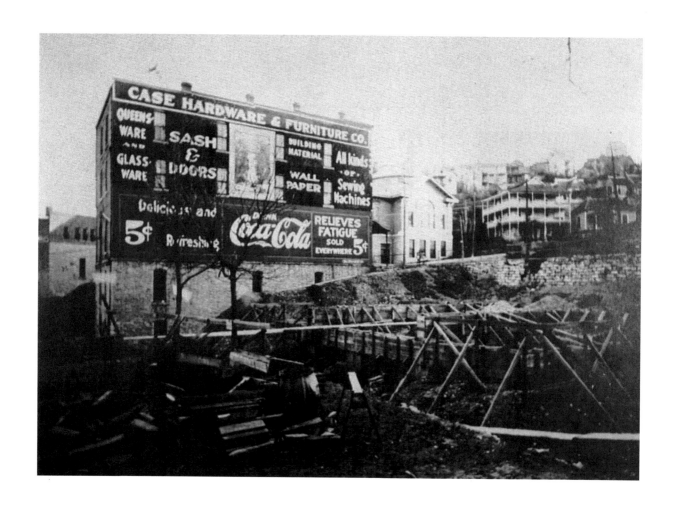

The Wadsworth Building on upper Spring Street in Eureka Springs
(Carroll County) as it was in 1916. Photo: *Eureka Springs,
A Pictorial History*, Eureka Springs Public Library
Association, 1975, plate #71.

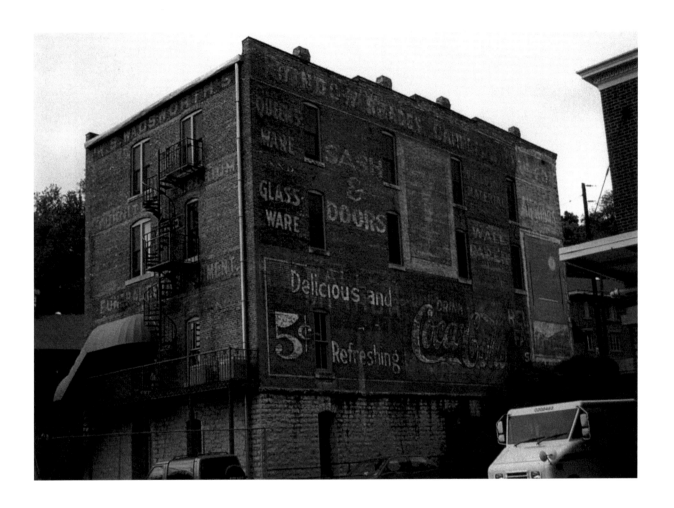

The Wadsworth building as it is today. *1992*

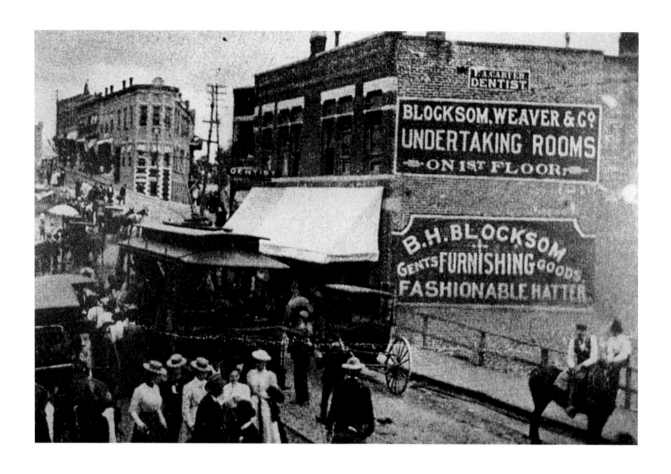

A circa 1902 street scene in Eureka Springs (Carroll County)
reveals the prominence of the Blocksom undertaking business.
Photo: *Eureka Springs, A Pictorial History,* Eureka Springs
Public Library Association, 1975, plate #63.

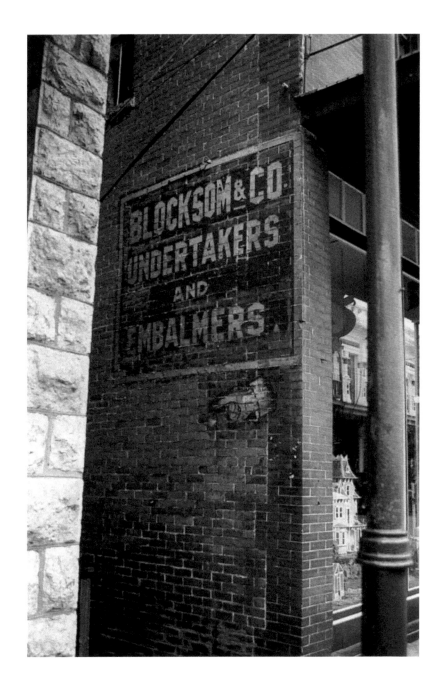

Today, this Blocksom sign still
points the way to the undertakers
in downtown Eureka Springs
(Carroll County). *1992*

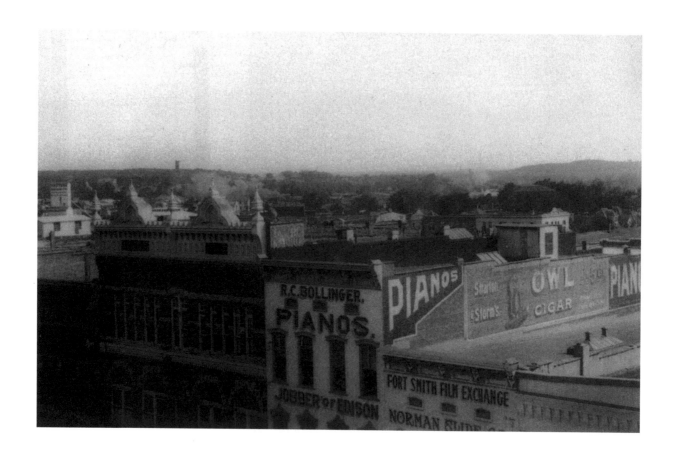

A circa 1910 photograph of an Owl Cigar sign on upper Garrison
Avenue in downtown Fort Smith (Sebastian County) is from the
Cravens Collection in the UALR Archives.

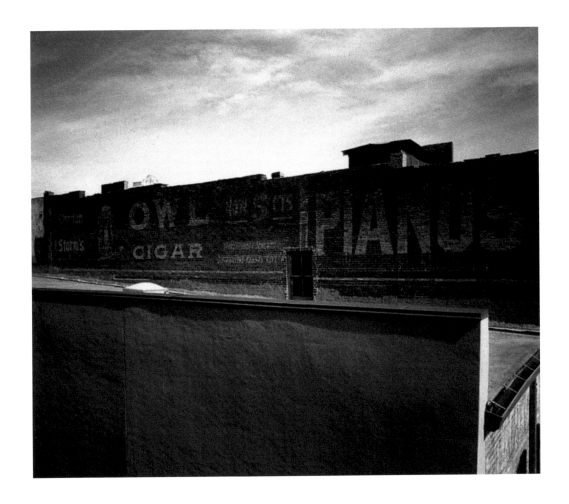

The same Owl Cigar sign as it appears today. It was probably painted between 1897 and 1906, because the parent company, Stratton and Storm, sold out of business around this time period. *1991*

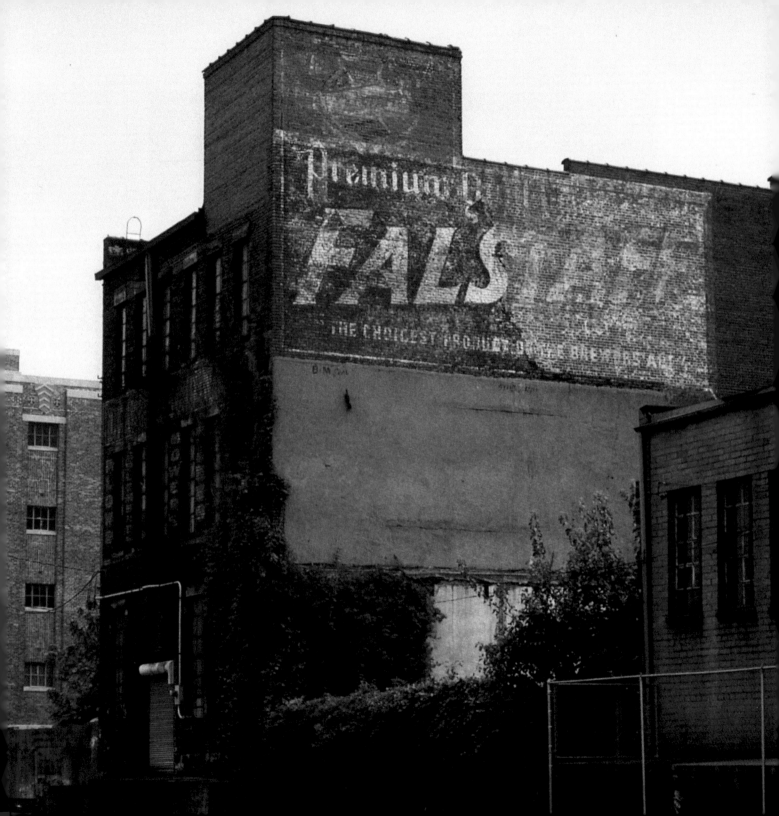

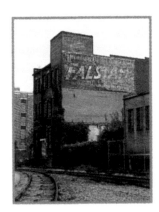

WALL DOGS

The Falstaff Beer sign on East
Markham in downtown Little Rock
(Pulaski County) could be seen from
the Main Street bridge coming from
North Little Rock. It was ordered
by the local distributor, Mr. Joe
Calderera, and was painted by Bob
Adair and his son-in-law, Kelly
Kemp, in the early 1950s. It
perished in November 1995 when
the building was razed to make way
for new construction. *1990*

THE gentlemen depicted on the following pages are
representative of the many sign painters whose work
honored the walls of buildings across Arkansas.

~

ROBERT H. (BOB) ADAIR is the among the last of a breed of "wall
dogs" who brought painted brick wall signs to life in Arkansas
during their heyday. Beginning in 1924 as a helper to James J.
Dollins sign company in Little Rock, his career spanned sixty-
eight years, with his last sign completed in 1992.

Many of the wall signs painted by Mr. Adair were for
bottling companies, including Dr Pepper, Grapette, and Coca-
Cola. Still others were for liquor companies such as Old Crow
and Jim Beam and for beer distributors such as Falstaff.

Mr. Adair's philosophy was, "If I can get to it, I'll paint it."
The huge wall expanses were often scaled with block and tackle,
which hoisted the painters up the wall with the help of ropes
tied to a car bumper. Other types of wall scaffolding consisted of
a "swing stage" that was secured by ropes and attached to the
building parapet.

Besides wall signs, Bob Adair also painted company names
and logos on numerous trucks and highway billboards and even
applied the names of corporate sponsors to the sides of race cars.

Mr. Adair as a master sign painter not only taught the craft
to the many who followed, but he also was instrumental in the
development of some of the techniques and materials used in the
sign painting business today. A. J. Anderson of Mizell Sign
Company in Little Rock attributes some of his know-how to the
teachings of Mr. Adair when the two joined forces in the early

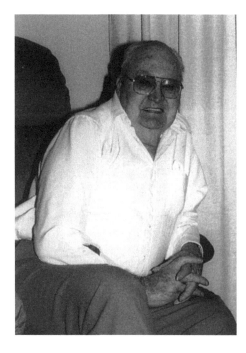

Bob Adair

1970s. Besides learning a few tricks of the trade, Mr. Adair's attitude toward life inspired him to keep on going when things got tough. When asked how he managed to be happy every day, Mr. Adair would simply say, "I trick my mind into thinking I'm having fun." This attitude adjustment always applied, even to those times when he found himself hoisted high above ground in 100-degree heat.

Many of the old-time sign painters are no longer living. Some of the masters remembered by Mr. Adair are James J. Dollins, Frank Maxstead, G. W. Blankenship, G. W. Fallis, Bo Franklin, the Vaughter Family, Dillon Mizell, Lucious Beaumont, Sam Peters, and Miller Smith, all from Arkansas, and Mickey Richart of Shreveport, Louisiana.

~

A. J. ANDERSON of Mizell Sign Company in Little Rock worked with Bob Adair for twelve years and attributes much of his know-how to his association with this master sign painter.

Mr. Anderson, a master himself, began his career while still in high school as an apprentice to sign painter Lee Hinson. After graduation, he went to work for Sam Peters, owner of Ace Sign Company in Little Rock. During his early tenure, his work included painting political signs on the walls of the hotels that once lined Markham and Main Streets in downtown. Before the explosion of televised political advertisements, candidates would have their images and slogans painted across the sides of buildings in promotional campaigns similar to those used to advertise products.

Around this time, Mr. Anderson began to moonlight for Mr. Dillon Mizell, owner of another local sign shop. He eventually went to work at Mizell full time, taking over when Mr. Mizell died. When Bob Adair joined the shop, the two of them would work as a team, often "eyeballing" as they went, which meant drawing the design to a rough scale on the ground and freehanding the graphics on the wall without the use of grid lines. According to Mr. Anderson, one would lay it out on the wall in charcoal, and the other would follow with a brush, filling in with color. Sign painting is a difficult craft, and it often takes as much artistic talent as mechanical skill to ensure that a sign not only looks good, but is proportionally correct as well.

Mr. Adair retired in 1992, and A. J. Anderson

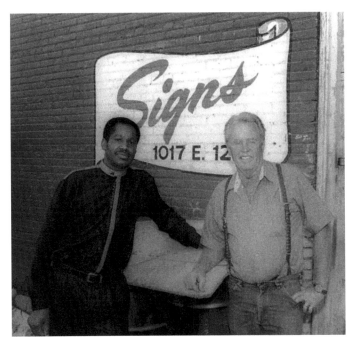

Lynn White and A. J. Anderson

watch a sign painter at work. He began studying the craft, and by the time he met Mr. Adair, he had developed enough self-taught experience to "ride around with him and help." As he worked and learned, he mastered the craft well enough to take a job with A. J. Anderson at Mizell Sign Company, and there, he honed his skills.

One such skill, according to Mr. White, is the ability to judge scale and proportion well enough to start at any point in the lettering or graphic and paint the sign to fit the space. To prove himself to a skeptical client, he once had to paint lettering for the word "Solarcaine" backwards, from right to left, on a large billboard.

With the help of A. J. Anderson, Mr. White has also developed a specialty in the art of gold leaf. Using 23-carat gold-leaf sheets and a tool called a guilder's tip, pieces of the very thin gold leaf are carefully placed on the surface. This technique requires multiple steps and a lot of patience, and can be very expensive. Mr. White has "gold leafed" signs on doors at the Capitol building and on the seal atop the Old State House in Little Rock.

has continued with the shop, serving many clients for more than twenty years. Today, sign shops such as Mizell Sign Company must remain in demand by creating signs and graphics for businesses such as trucking companies, real estate companies, awning companies, advertising firms whose promotions are found on large billboards, and grocery chains that use large banners to entice the passer-by.

≈

LYNN WHITE is another master sign painter who was associated with Bob Adair. After several years in another career, Mr. White became fascinated with the art of sign painting after one day stopping to

Currently, Mr. White works for Rainbow Sign Company in Jackson, Mississippi. The teachings of masters such as Bob Adair and A. J. Anderson have served him well. He enjoys creating something he is proud of, and considers sign painting rewarding, even when the weather is rough and the scaffold is high.

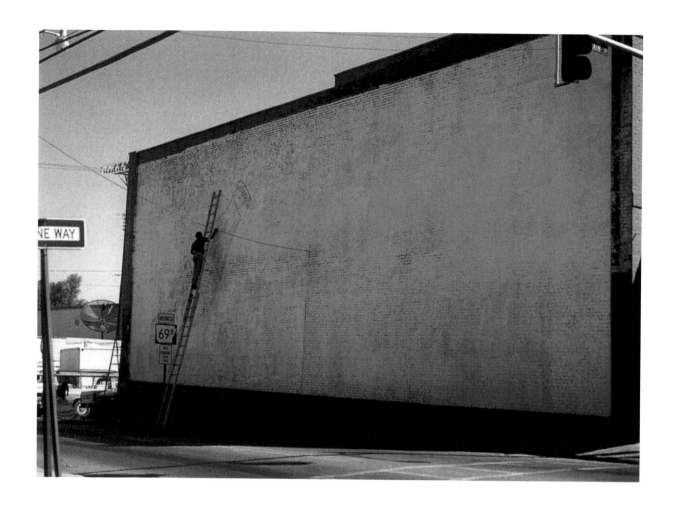

In 1988, the city of Batesville commissioned Lynn White to re-create a
Coca-Cola sign featuring the popular "Sprite and Bottle" design from
the early 1940s. Its creation, from start to finish, is presented on the
following pages. (Photographs by Dave Timko, Main Street Batesville.)

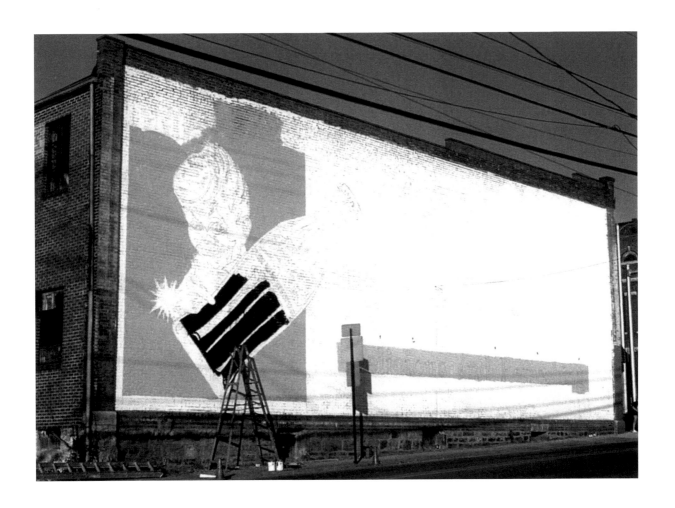

The logo began as a line drawing, with a band of
yellow where lettering would be placed.

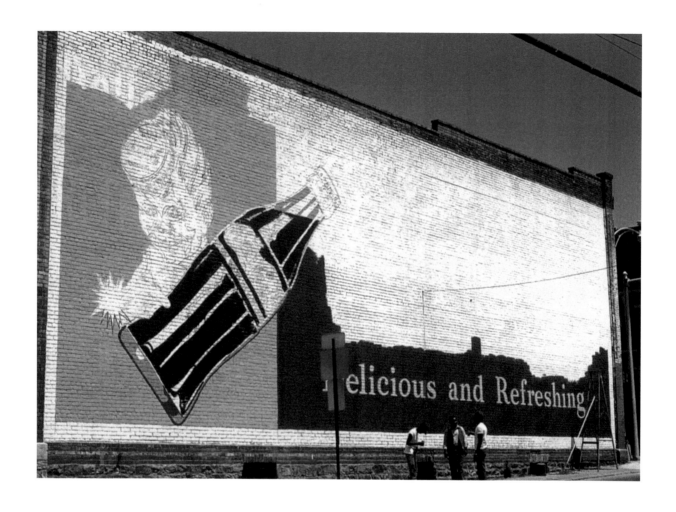

Large blocks of color were laid out, with the bolder red background
filling in the spaces around the yellow lettering.

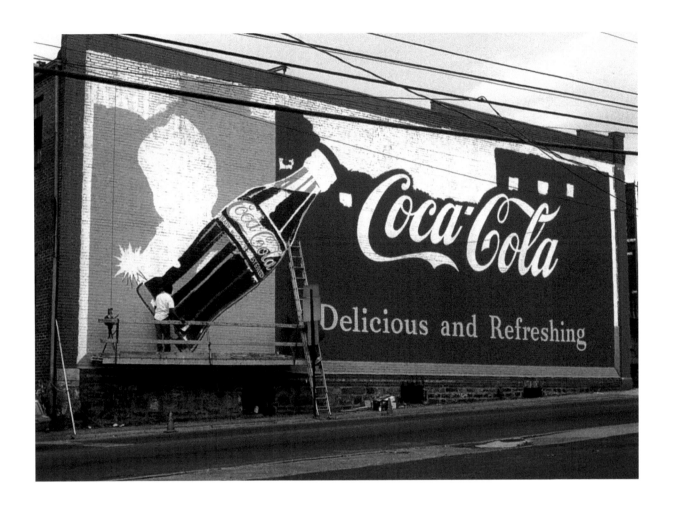

The use of moveable scaffolding allowed access
to all areas of the large vertical canvas.

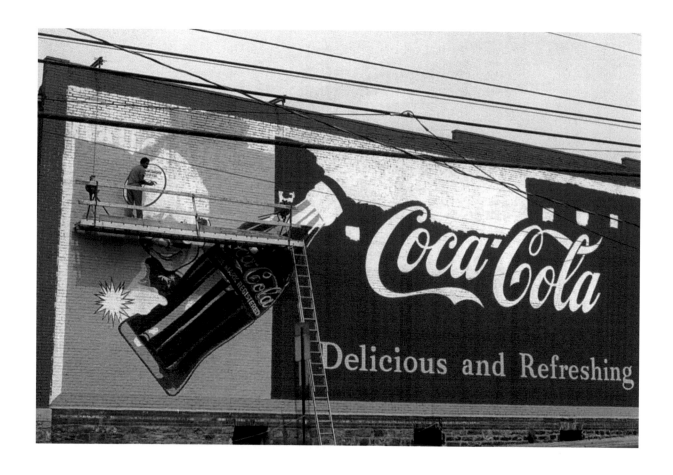

Details were filled in according to graphic and paint specifications that
are located in the Coca-Cola company archives in Atlanta, Georgia.

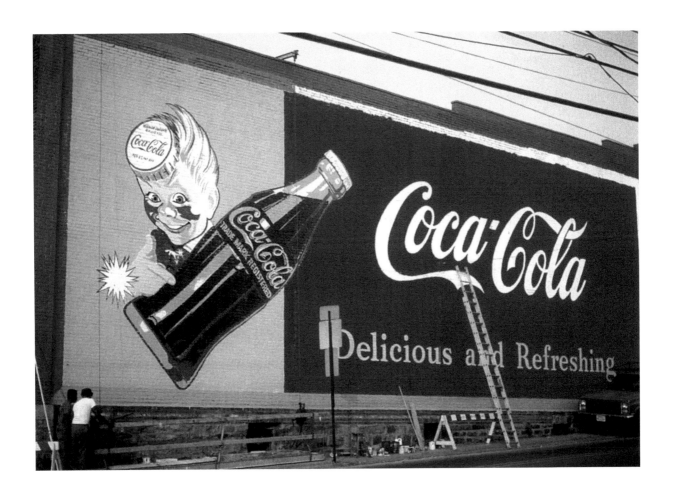

The finished sign has become a welcome
addition to the downtown area.

Privilege Signs

Instead of a pictorial advertisement, a catchy slogan said it all in a section of downtown Fordyce (Dallas County) near the railroad.

1990

PRIVILEGE signs represented the calling card of the establishment. To secure space for the sign, a deal was made in the form of a "privilege." If the product being advertised was sold at the business, or if the location was desirable, the merchant's name and type of store would often be included in the advertisement as a favor for the use of the wall space. This type of deal-making was called a swap. "I'll paint your sign if you let us paint ours," were words often stated as part of standard procedure.

The lettering was hand-painted by skilled sign painters who field-measured proportions using brick dimensions, snap lines, and other common-sense techniques to create the depictions that could be seen from afar. The privilege sign was usually white lettering on a black background and was typically painted above the actual advertisement. The white pigment was called "white lead" and had a paste-like consistency that resembled shortening. The color black was often made from lampblack, a finely ground powder that looked like soot. Each substance was mixed with the right amount of varnish and linseed oil along with a drying agent like gasoline. The results were usually lasting. Because of the painter's craftsmanship and the durability of the materials, the privilege signs reveal a recon-structable history about a community and its people.

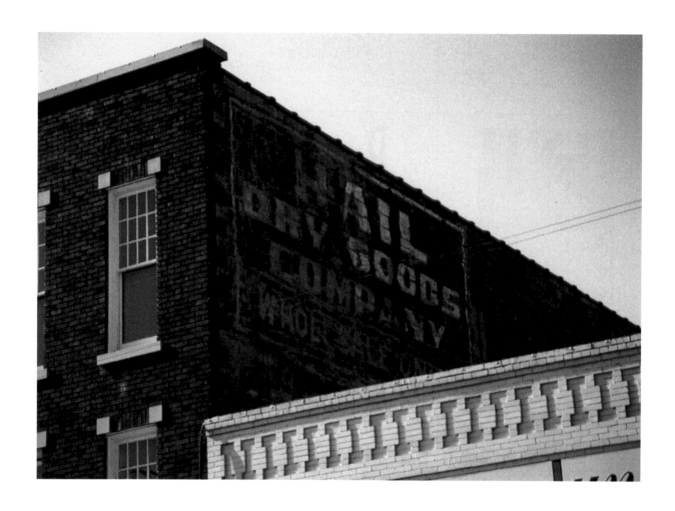

A sign painted on the side of a building in downtown Batesville
(Independence County) is rare in northern Arkansas because the
dominant building material is stone instead of brick. *1991*

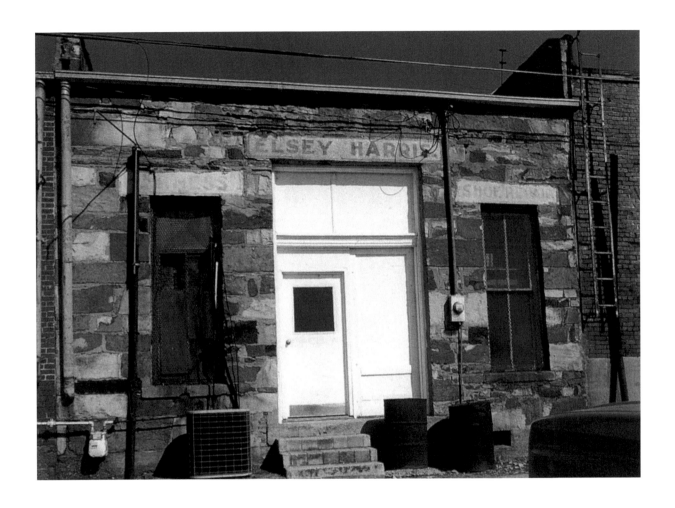

A simple privilege sign offers only the name of the
merchant who operated this long-gone business on
Commerce Street in Ozark (Franklin County). *1990*

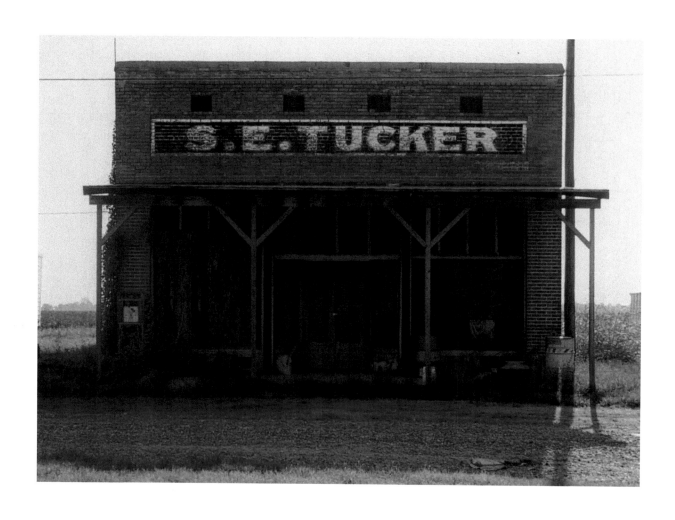

A former retail establishment stands alone on Highway 15
in Tuckerman (Jefferson County). *1993*

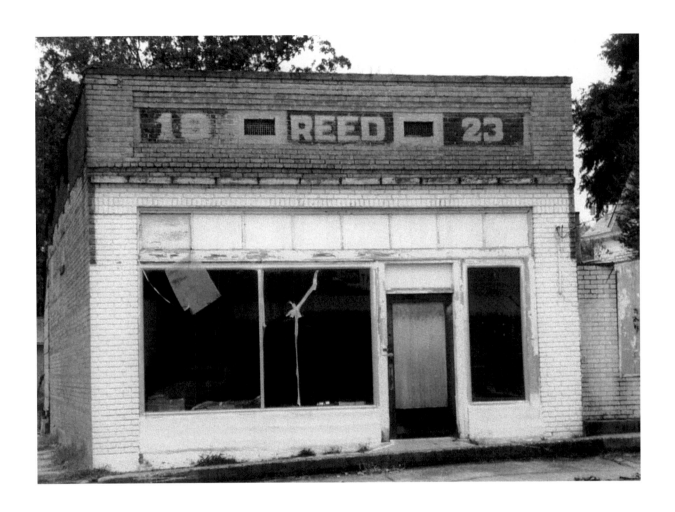

A 1923 privilege sign told the name of the merchant who operated this
long-gone business on South Market Street in Benton (Saline County).
This building was razed soon after this photo was taken. *1991*

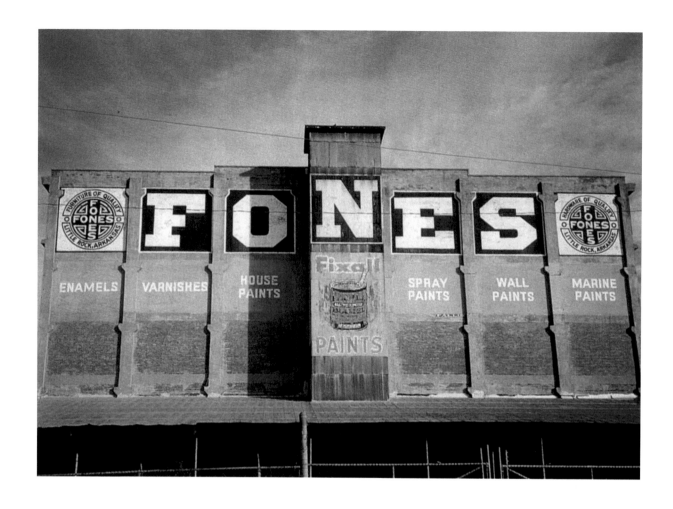

The large warehouse building on Cumberland Street in downtown
Little Rock (Pulaski County) displayed a reminder of the Fones
Hardware Company. The black and white privilege sign remained
clear over the years. It was destroyed in 1996 during renovation
of the building for use as a library. *1990*

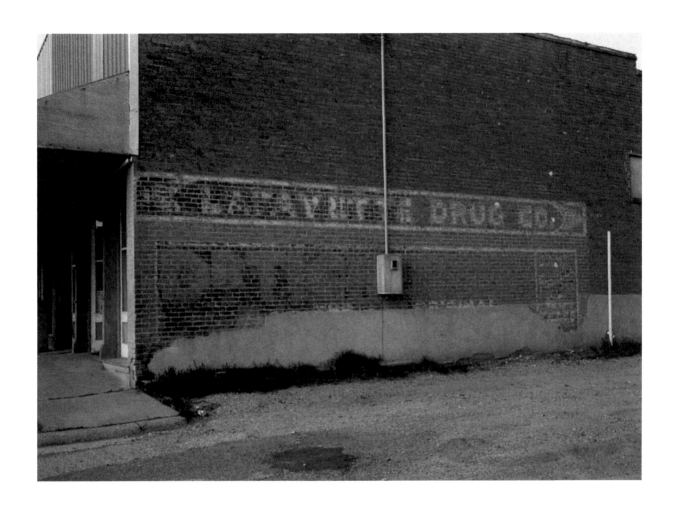

The privilege sign is in a typical location on the side wall of this old drugstore in Stamps (Lafayette County). Photograph by Dr. Frank Schambach, Arkansas Archeological Survey, SAU Magnolia. *1989*

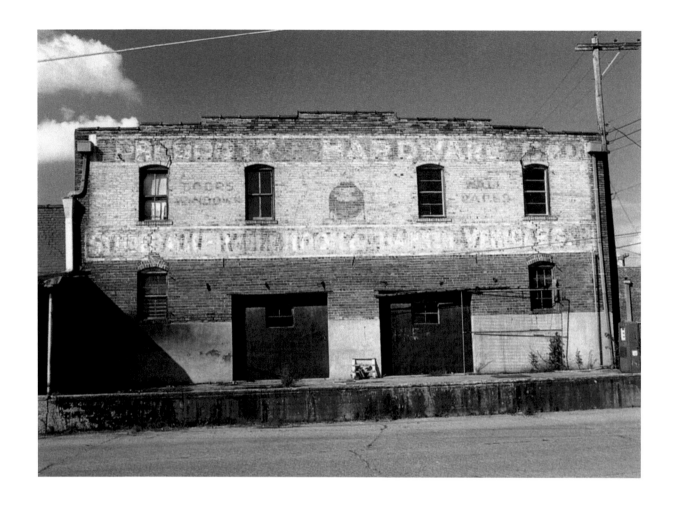

In Prescott (Nevada County), a Sherwin Williams Paint sign with the slogan "We Cover the World" was placed between two privilege signs. The black backgrounds have faded over the years, indicating that the substance called lampblack was probably not used. *1990*

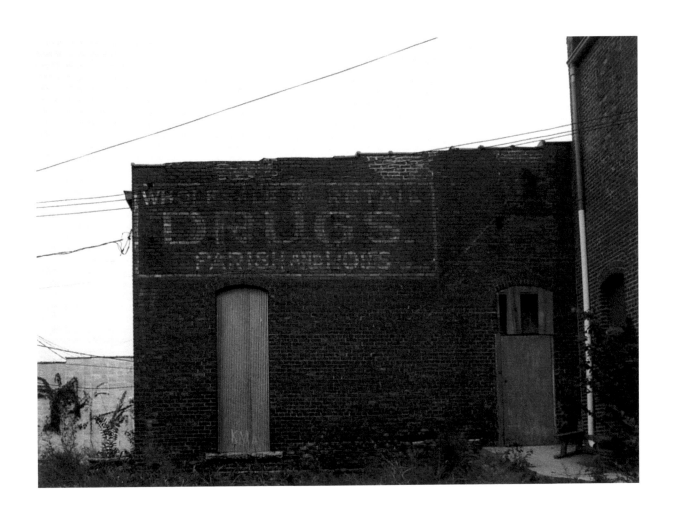

A now obscure privilege sign recalling an old drugstore is found
in a back alley in Booneville (Logan County). *1991*

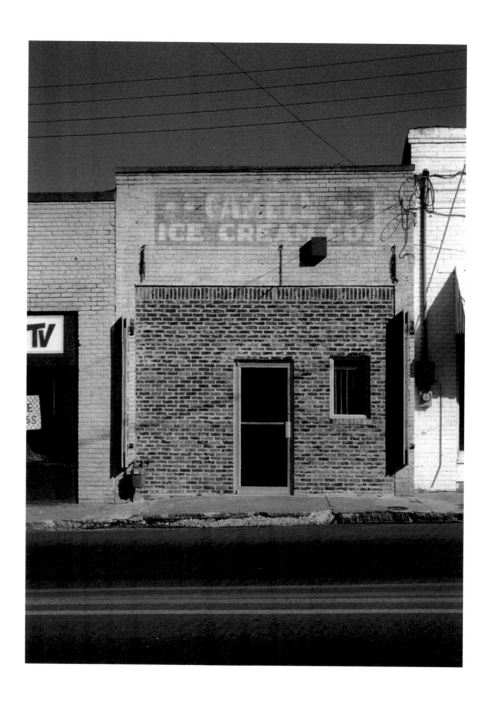

Camell Ice Cream
Company in Camden
(Ouachita County). *1991*

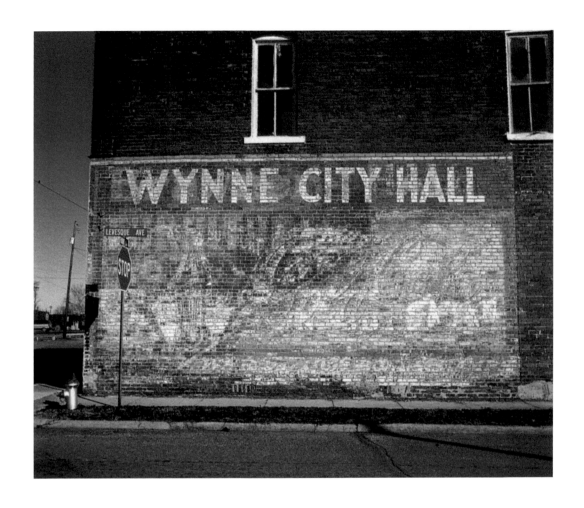

This building housed the Wynne City Hall
(Cross County) from 1918 to 1954. *1992*

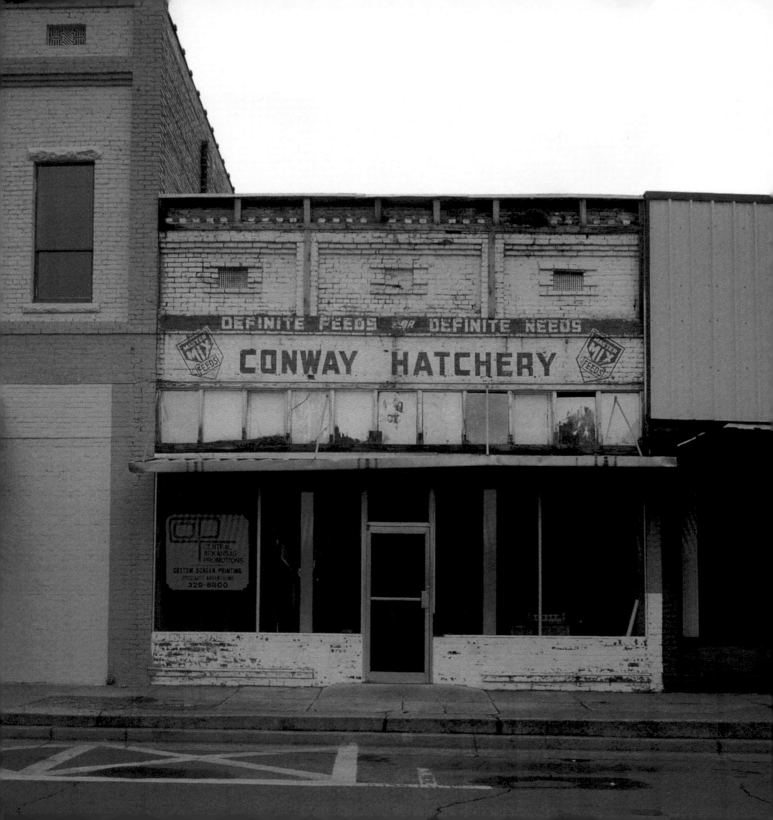

HAWKING
THEIR WARES

E ARLY retail stores generally advertised clothing, hardware, or dry goods. As towns grew, specialty stores began to emerge, selling everything from tonics to engine oil products. In the old days companies would send advertisement layouts to the various product dealers who would then obtain bids from different sign painters. The winning "wall dogs" would paint the sign, take a photo, and send it to the company as proof for payment.

Many of the products are no longer around, nor are the merchants who sold them, nor the sign painters who created the images. But the old wall signs reflect their remaining legacies as they call forth recollections from those who were there to witness the time when the business or the product prospered.

This old feed store sign in downtown Conway (Faulkner County) was uncovered when metal siding was removed in 1992. It was painted over during subsequent remodeling and is now gone.

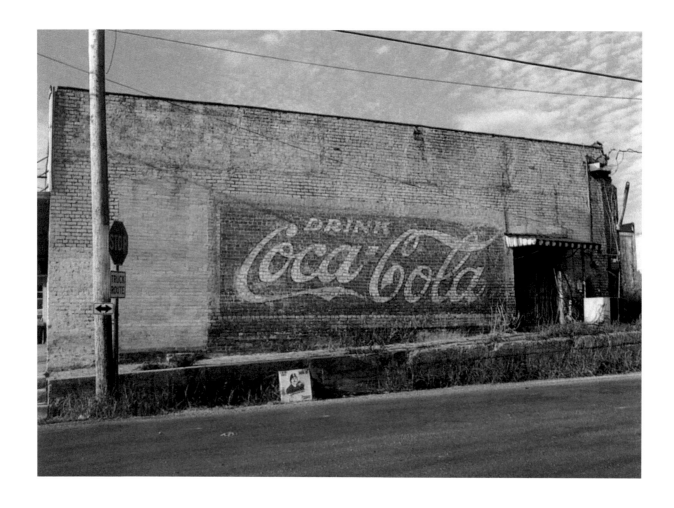

The first wall sign painted for Coca-Cola was done by a salesman in
Cartersville, Georgia, in 1894. Early coke signs often said "Drink
Coca-Cola" as this one does in Fordyce (Dallas County). *1990*

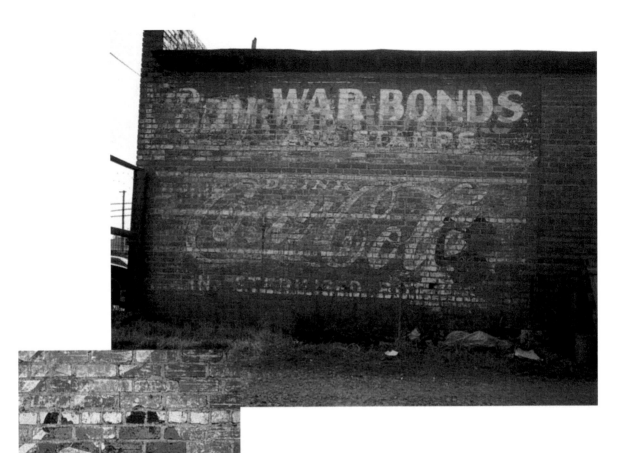

A 1930s pictorial Coca-Cola design, "Silhouette Girl," sits below an early 1940s advertisement for war bonds on the side of a former railroad cafe in Bald Knob (White County). During World War II, trainloads of soldiers flooded this establishment and others like it in order to refresh themselves before moving on. *1991*

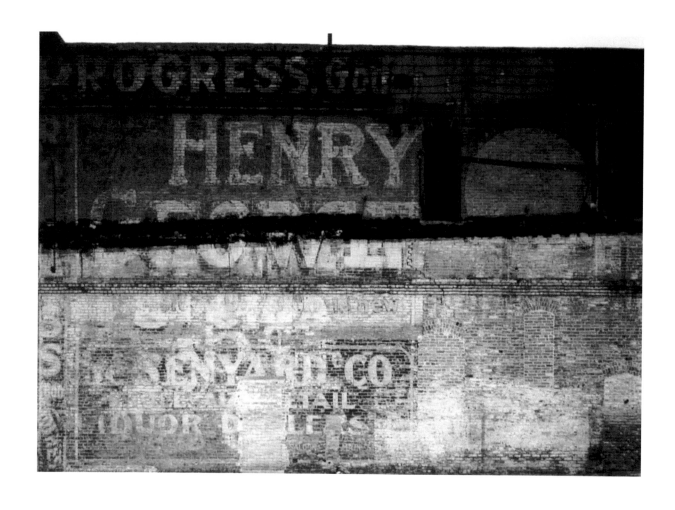

What was "Henry George?" Layers of signs on this wall in
downtown Pine Bluff (Jefferson County) indicate it was probably a
choice advertising location at one time. *1993*

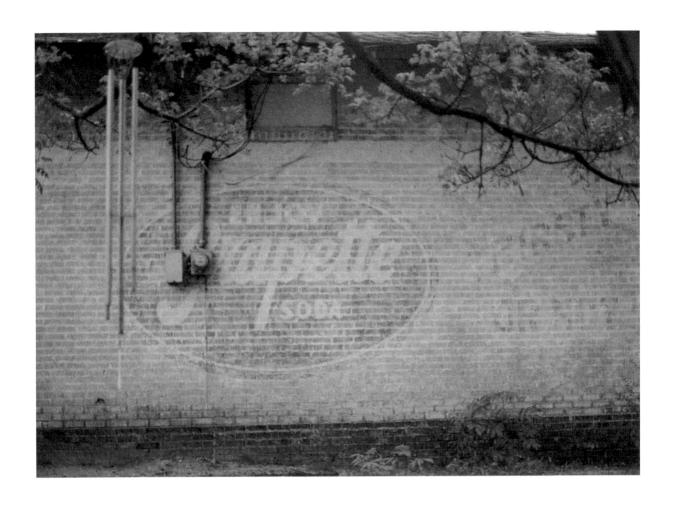

Grapette was started in Camden, Arkansas, in the late 1930s by
Mr. B. T. Fooks. Remnants of Grapette signs such as this one on the
side of an old gas station in Smackover (Union County) can still
be found in south Arkansas. *1989*

Polarine was an engine oil product manufactured by Standard Oil
Company that was discontinued in the 1930s. Oil companies were
among the first to realize the selling potential of large wall spaces.
This sign on Chestnut Street in downtown Conway (Faulkner
County) is one of a few still in existence. *1989*

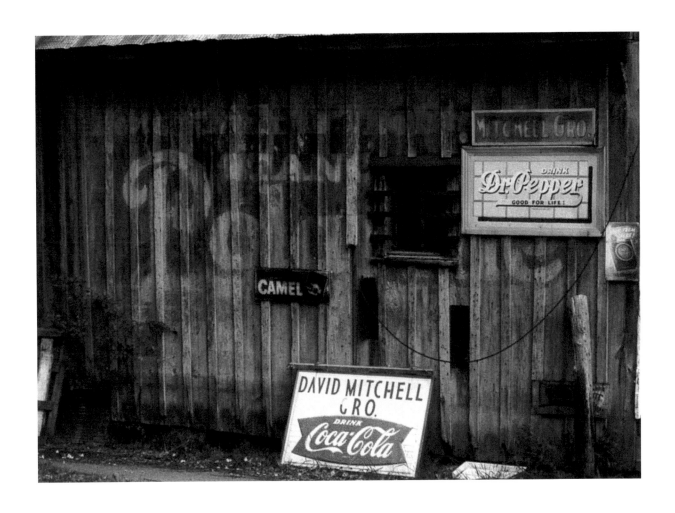

Another Polarine sign in Stamps (Lafayette County), 1989.
Photograph by Dr. Frank Schambach, Arkansas
Archeological Survey, SAU Magnolia. *1989*

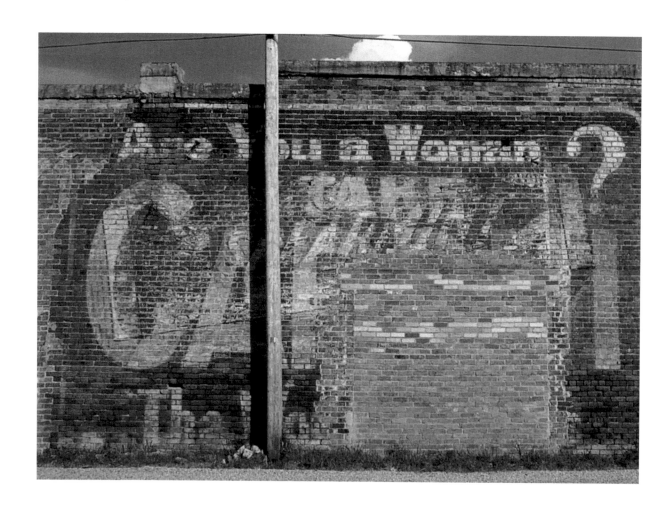

Carduii, a tonic for women, still dominates this old Spearmint Gum
sign on a wall in Prescott (Nevada County). "A baby in every bottle"
was an informal slogan denoting this elixir. *1990*

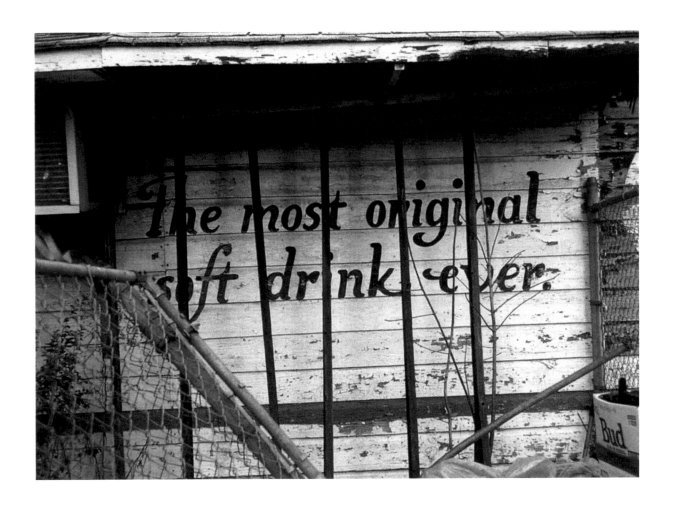

An early Dr Pepper slogan remains on a building
in Halliday (Greene County). *1991*

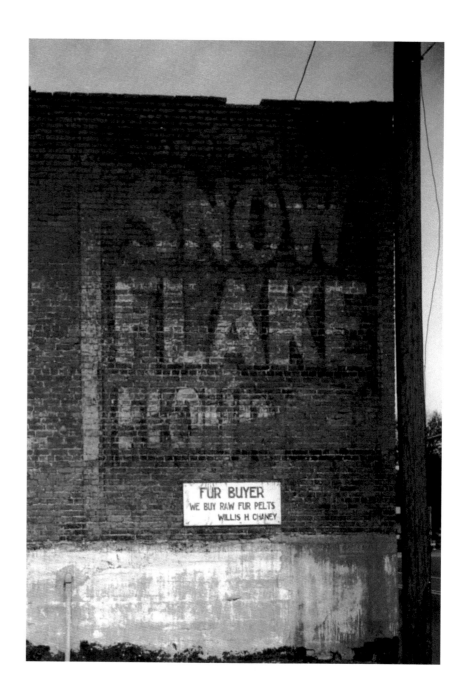

This ghost sign for Snowflake Flour in England (Lonoke County) touts a brand that is now obsolete. *1993*

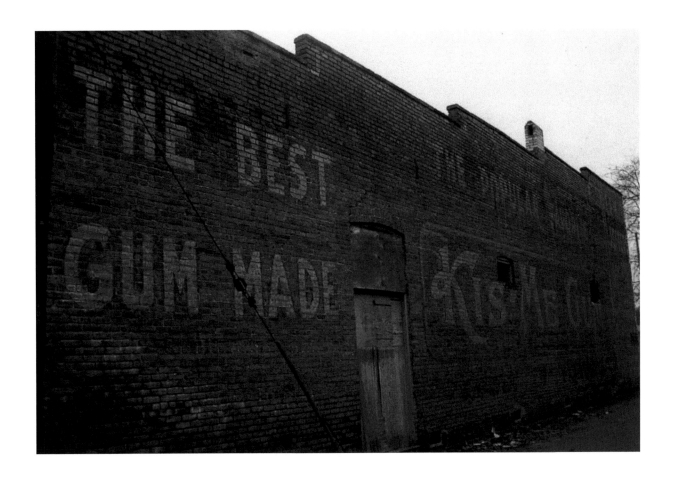

An ad for Kis-Me-Gum is still located in an alley
in downtown Brinkley (Monroe County). *1994*

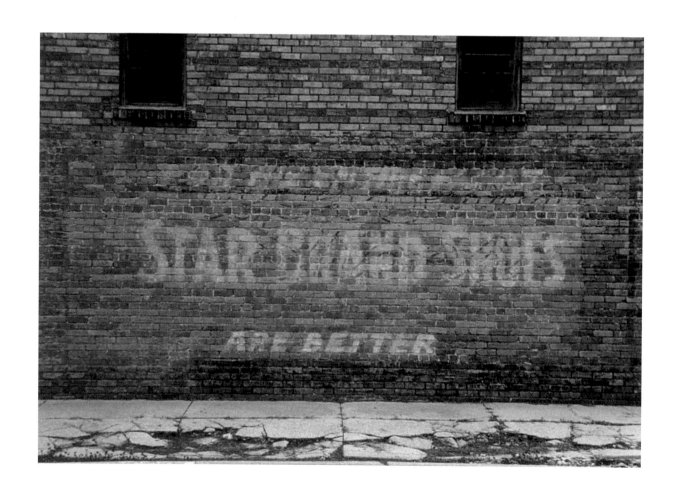

An early 1900 brand of shoes is still advertised on a building
around the square in McGehee (Desha County). *1991*

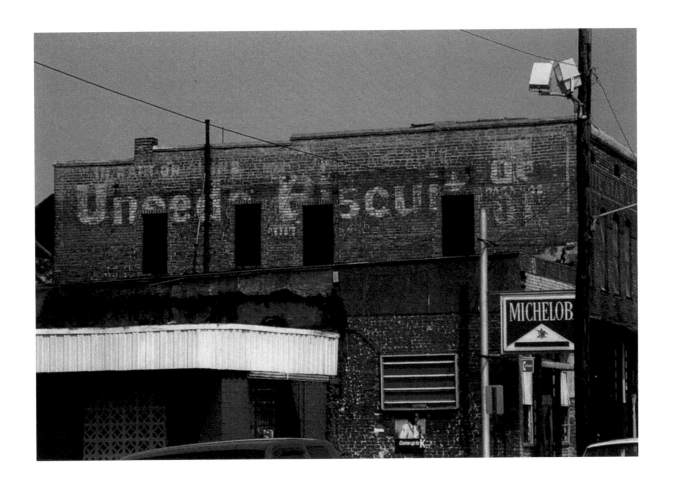

This Uneeda Biscuit sign still graces the side of a building in the older section of downtown Pine Bluff (Jefferson County). This product was once associated with the Nabisco Company. *1993*

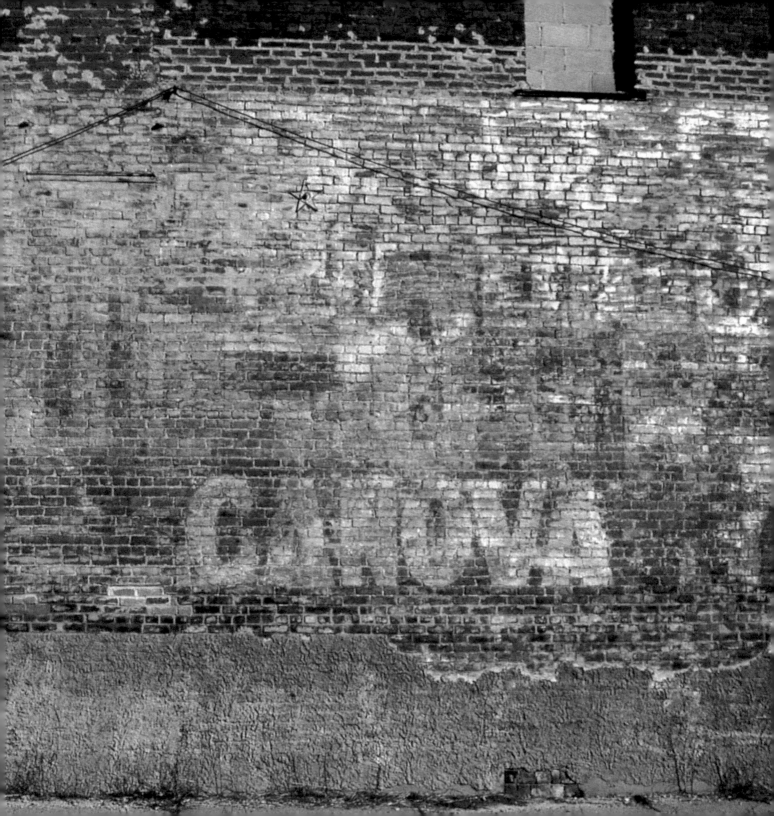

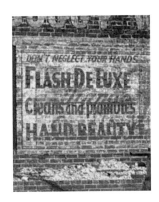

SIGN LANGUAGE

DUE to the staying power of the paints that were used, not only are ghostly effects created, but wonderful anachronisms—words that seem chronologically out of place—leave messages that serve as reminders of times past.

Like privilege signs, these messages will also provide clues to history. Their kind represent the last remaining traces of a time when the business, product, or vocabulary was in its heyday.

"Canova" was a brand of coffee, according to an old-timer in Wynne (Cross County). *1992*

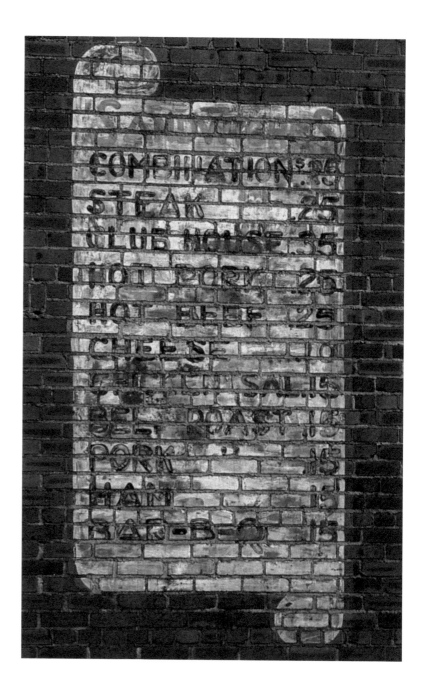

A closer look at this outdoor menu just off the square on South Jefferson in Magnolia (Columbia County) reveals prices unheard of in this day and time. *1990*

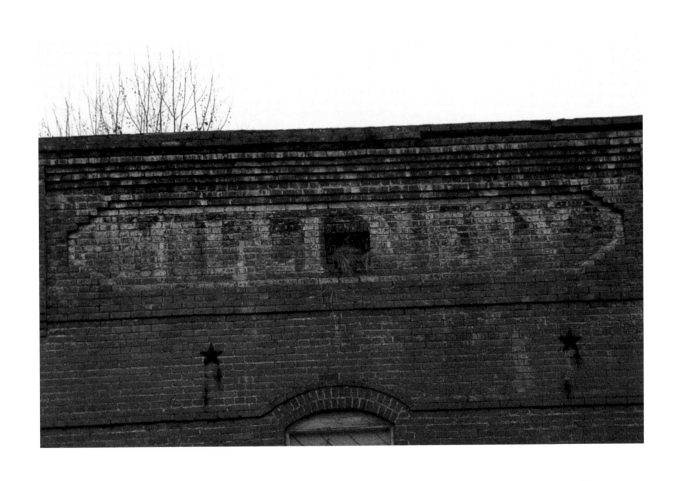

An old general store in Emerson (Columbia County)
sold many items including millinery, an old-fashioned
term for women's hats. *1991*

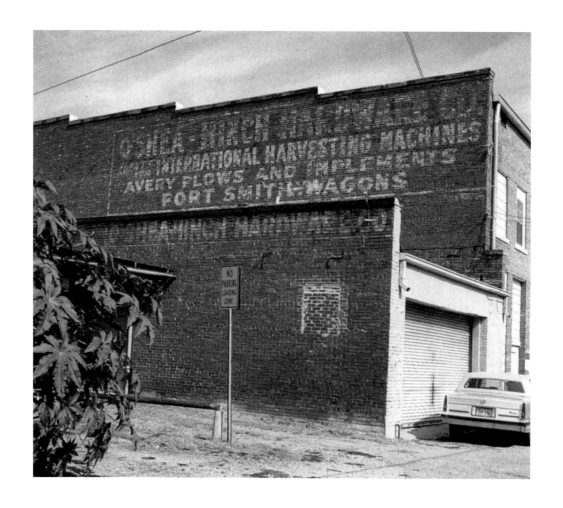

An alleyway ghost sign in downtown Fort Smith (Sebastian County) touts horse-driven wagons along with other farm equipment. *1991*

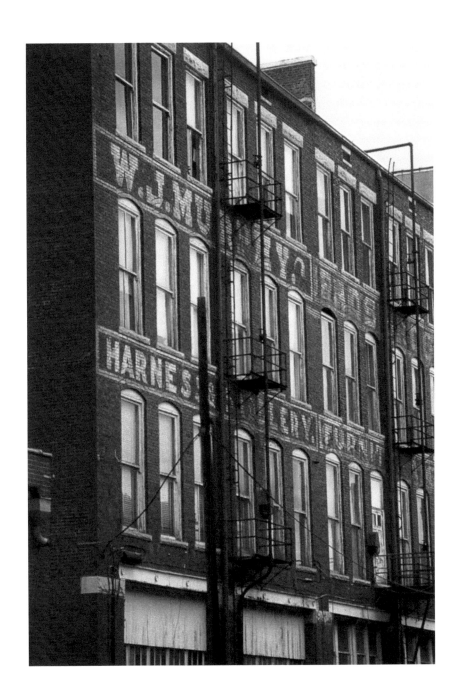

W. J. Murphy Harness
and Saddlery, Fort Smith
(Sebastian County). *1990*

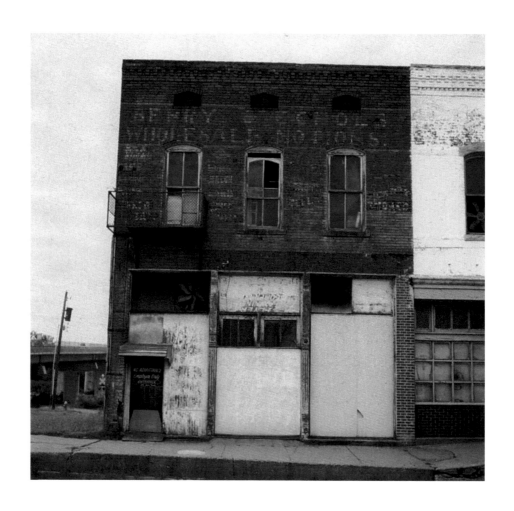

"Wholesale Notions" were located in this building near the
river in a very old section of Fort Smith (Sebastian County).
The building will most likely be razed due to heavy
damage by a tornado in May 1996. *1990*

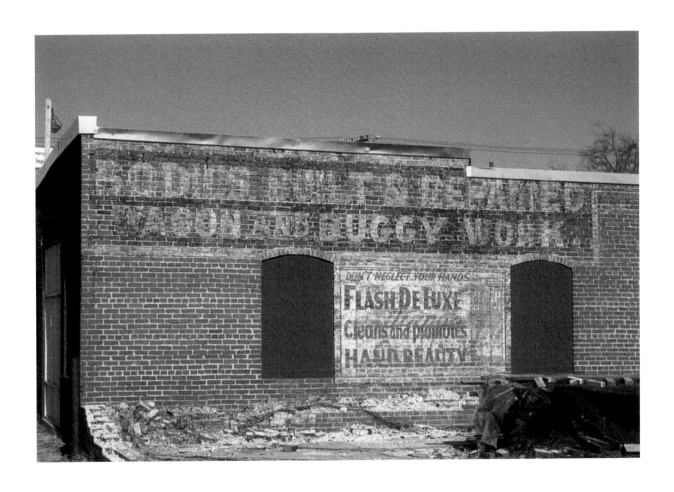

This sign advertises "wagon and buggy work" on Towson Avenue
in Fort Smith (Sebastian County). Note the ad for an
obsolete hand cream or dish detergent. *1994*

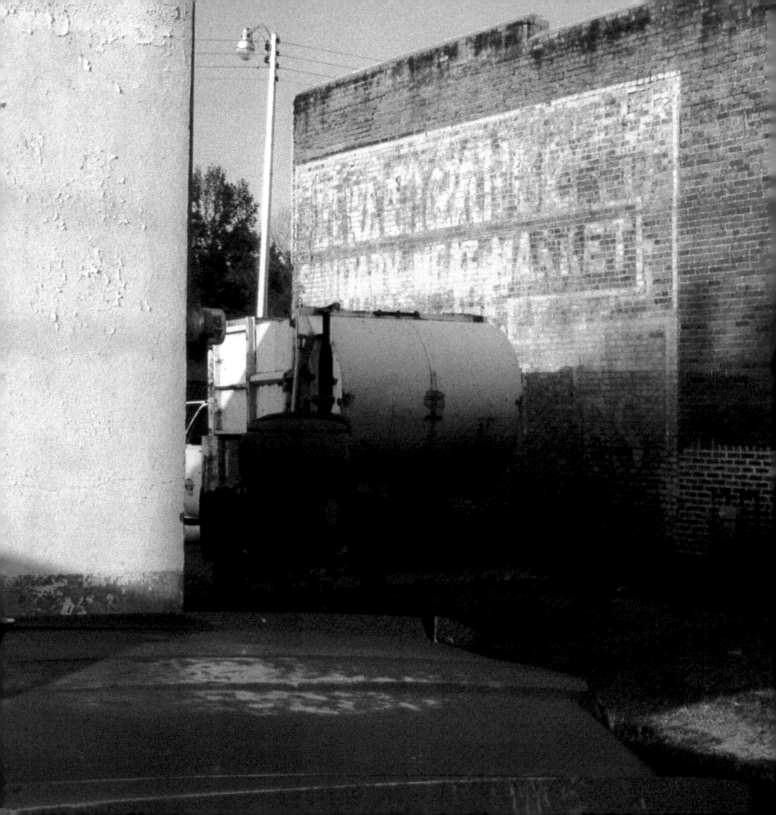

HAUNTS

SOME "signs of the times" can still be seen at corner buildings on busy intersections, on buildings facing a railroad, on structures along the highway, and in more obscure areas like back alleyways. The advertising appeal of a sign facing a busy intersection is obvious, and many companies such as Coca-Cola made it a priority to acquire the best locations.

Why, then, were many of these signs hidden in places that seem off the beaten path? The answers reveal that some signs indicated service entries while others were placed along former pedestrian paths that began to dwindle as the towns grew and the automobile became increasingly dominant.

The words "sanitary meat market" are read on a wall in Stamps (Lafayette County). Photo by Dr. Frank Schambach, Arkansas Archeological Survey, SAU, Magnolia. *1989*

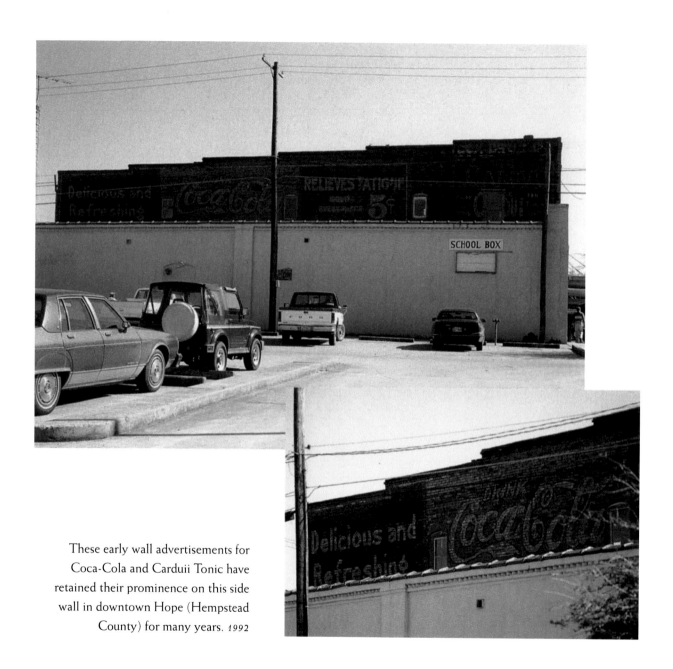

These early wall advertisements for Coca-Cola and Carduii Tonic have retained their prominence on this side wall in downtown Hope (Hempstead County) for many years. *1992*

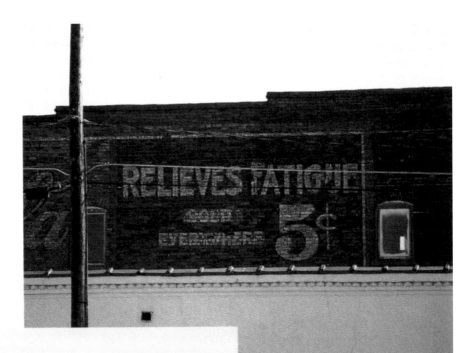

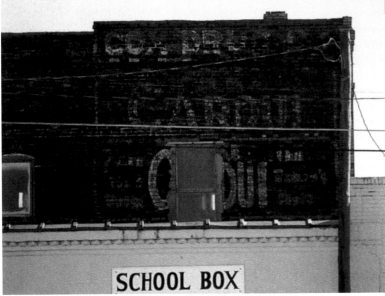

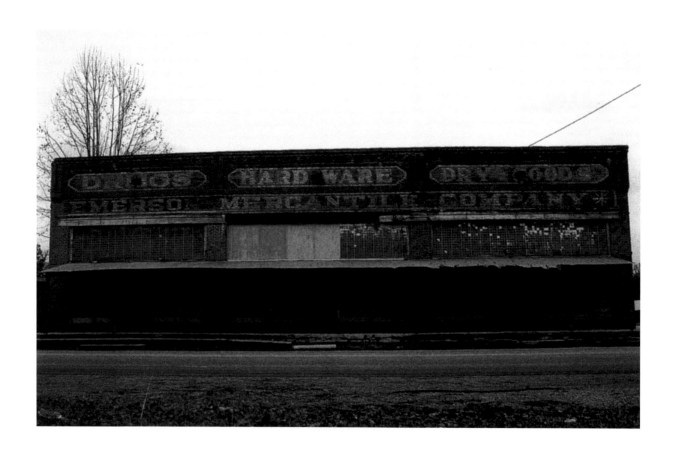

The old Emerson Mercantile Company building with its
many signs sits by the railroad on Highway 79 in
Emerson (Columbia County). *1991*

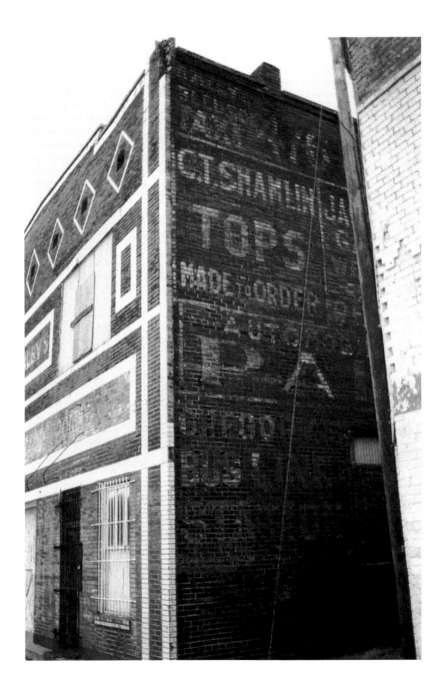

Signs painted in this narrow corridor in Blytheville (Mississippi County) may have embellished a one-time pedestrian path. These buildings have disappeared since this photo was taken in 1990.

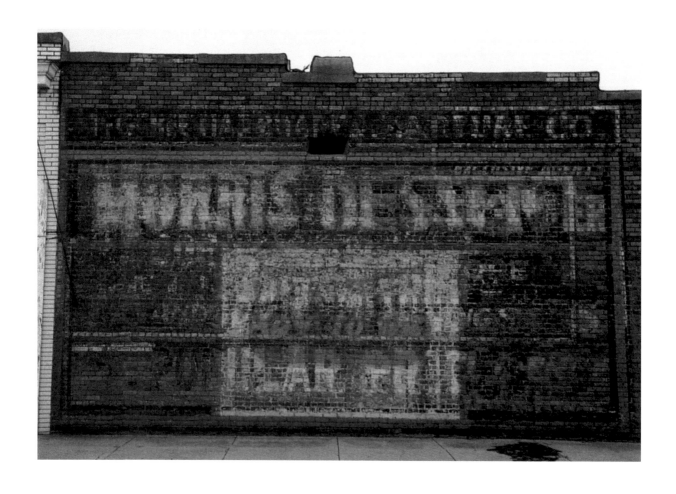

Even this sign with its garbled message in downtown McGehee (Desha County) still shows the typical location of the privilege sign. *1991*

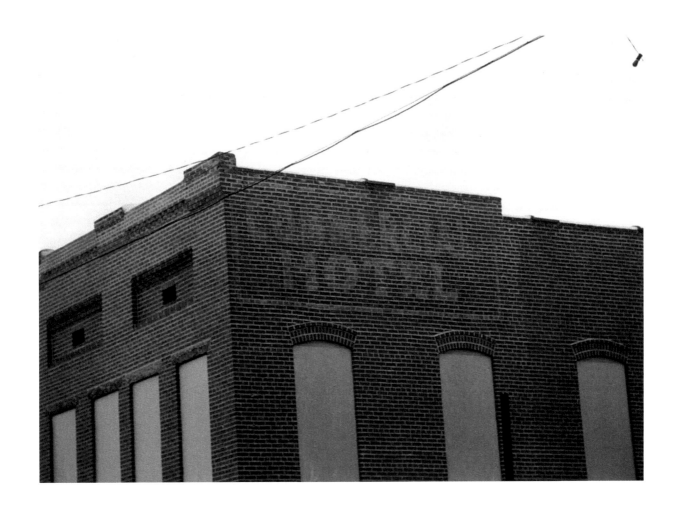

The old Commercial Hotel in downtown Paris (Logan County) still
haunts the upper-level corner of the building where it once existed. *1991*

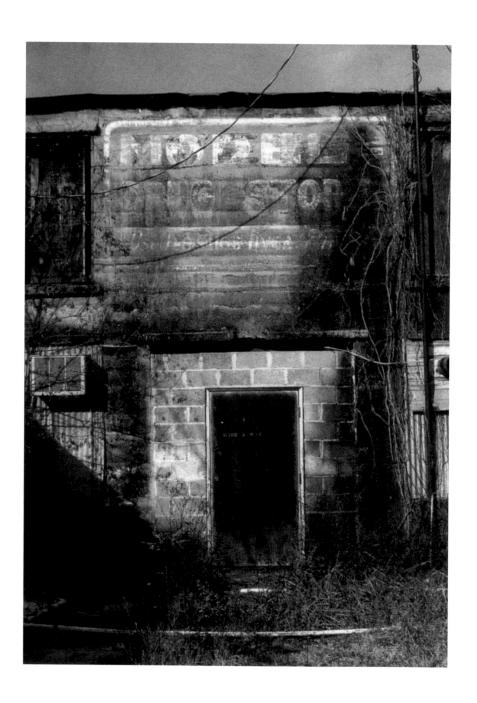

A remnant of a service entry
for a long-gone drugstore
still remains in Horatio
(Sevier County). *1993*

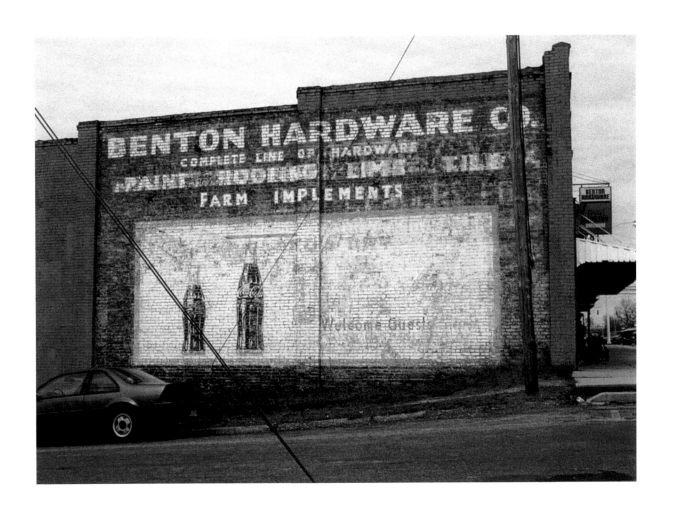

This must have been a prime location for Coca-Cola because
the Benton Hardware Company in Fordyce (Dallas County)
was given a large privilege sign. *1993*

Because the Coca-Cola Company liked to secure prime locations for
its signs, this location appeared to be unusual. This is one icon that
disappeared in Trumann (Poinsett County) when these buildings
were razed to make way for a new athletic facility. *1992*

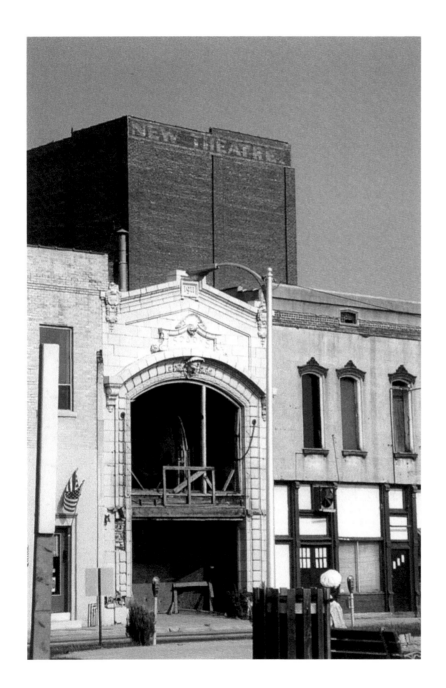

The New Theatre sign in Fort Smith (Sebastian County) probably took into account all viewers—pedestrians, automobiles, and even streetcar riders. The theater was built in 1911, but no longer exists. *1990*

The building's use has changed over the years, but this once-prominent sign is still visible in downtown Blytheville (Mississippi County). *1990*

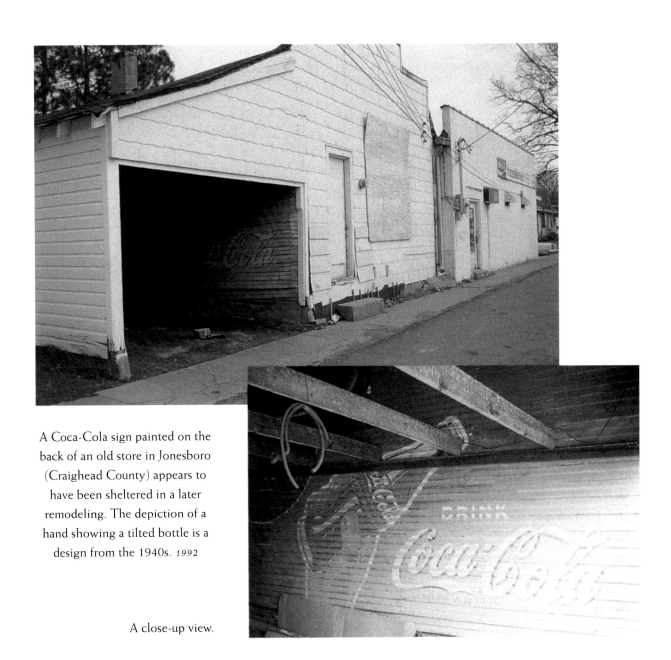

A Coca-Cola sign painted on the back of an old store in Jonesboro (Craighead County) appears to have been sheltered in a later remodeling. The depiction of a hand showing a tilted bottle is a design from the 1940s. *1992*

A close-up view.

Signs placed along the highway leading into a town were often
found on the sides of structures like this one on Highway 82
going into Magnolia (Columbia County). *1990*

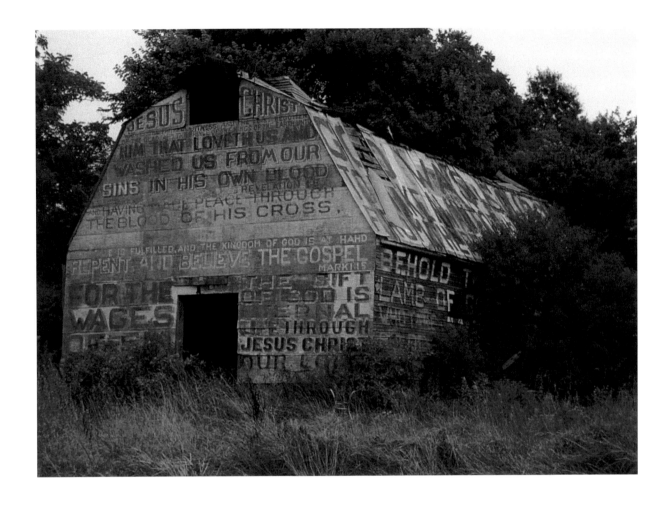

This barn on Highway 71 in Fayetteville (Washington County) served as a backdrop for religious writings. Signs found on the sides of barns are a rarity in Arkansas, and this example represents one of the last of its kind. *1994*

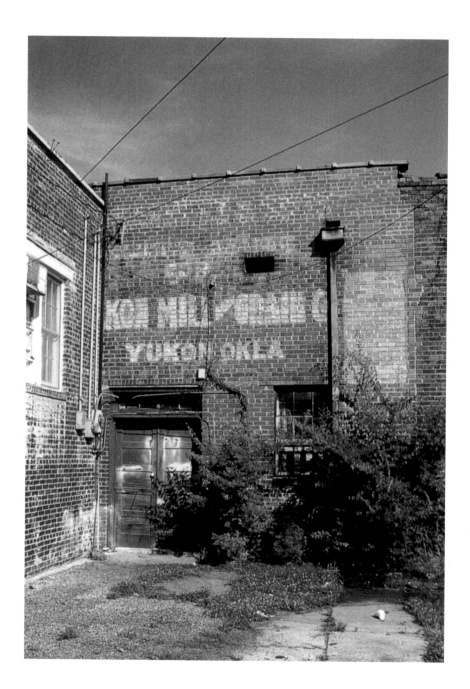

This Yukon Mills sign was partially covered when apparent additions were constructed. This may have been a service entry because it is located in an alleyway in downtown Prescott (Nevada County). *1990*

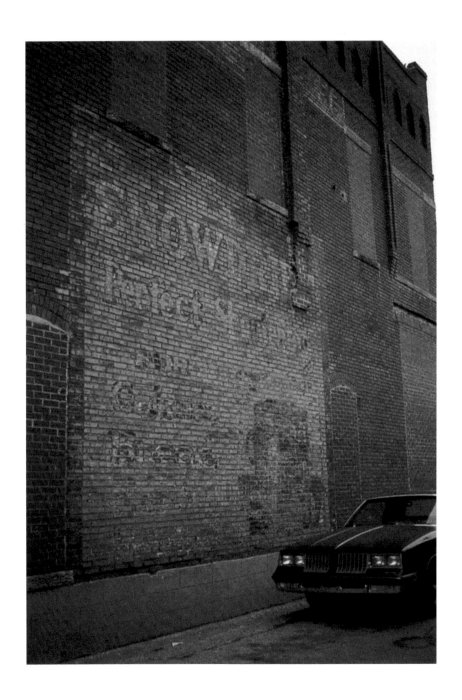

Because flour was such a common household product, many company signs have been found in the more obscure locations, such as this Snowdrift Flour sign found in the alleyway in Paragould (Greene County). Perhaps when it was painted, this was a pedestrian walkway. *1991*

Another sign advertising Optima Flour haunts the
alleyway in Prescott (Nevada County). *1990*

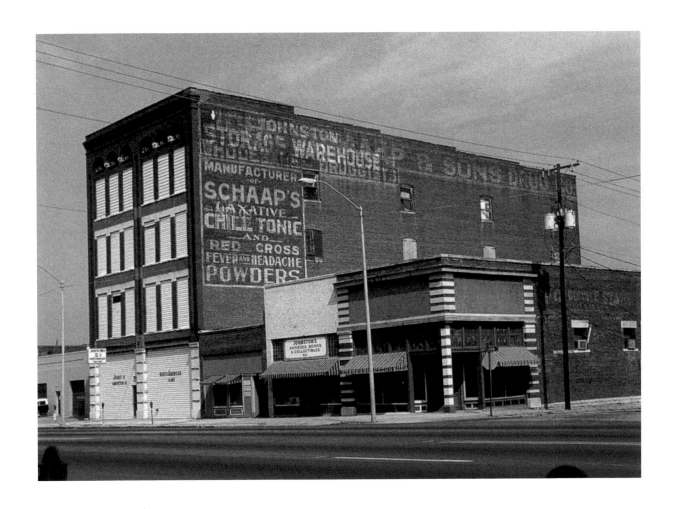

Many signs were placed so they could be seen from several blocks. For years, this large wall of old advertisements in Fort Smith (Sebastian County) faced traffic heading toward the bridge into Oklahoma. The building was destroyed by a tornado in May 1996. *1990*

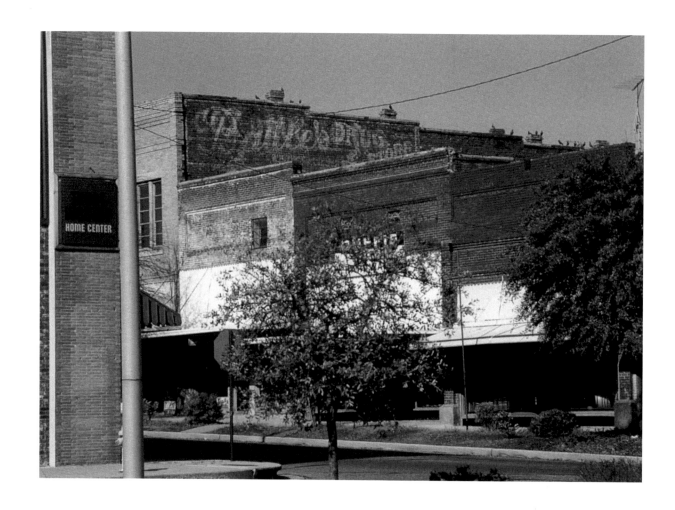

An old sign for a drugstore was placed on one of the tallest
buildings in downtown Hope (Hempstead County). *1992*

Turner's Garage once advertised United States Tires at an
intersection in Pocahontas (Randolph County). *1992*

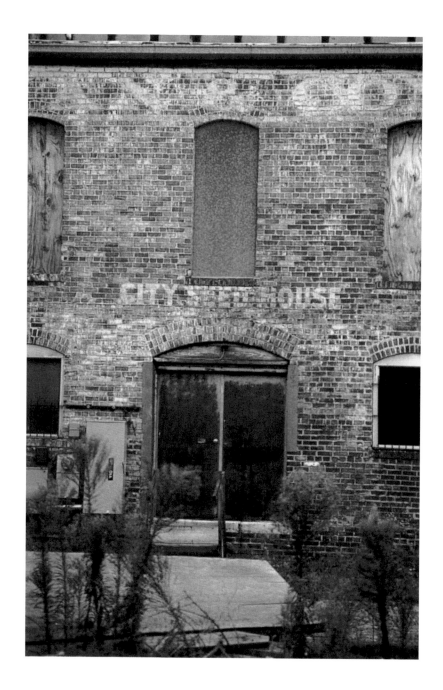

Located on the back of a
building in downtown Fort Smith
(Sebastian County), this sign must
have depicted a service entry for
the City Seed House. *1990*

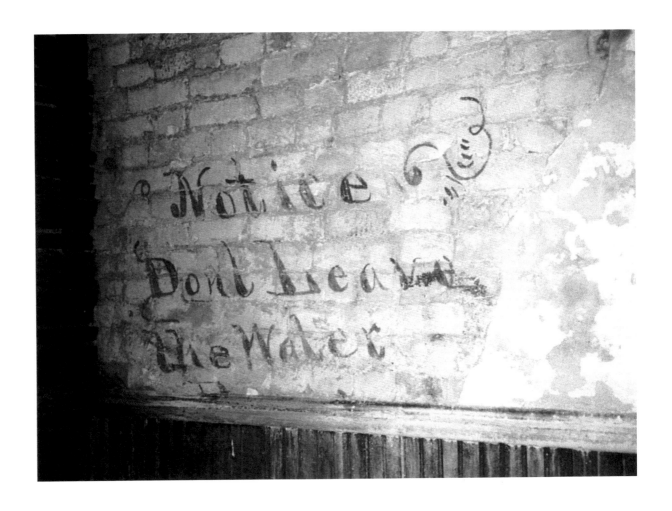

During renovation of an upper-level interior, the plaster was peeled
away to reveal an old reminder. Camden (Ouachita County). *1990*

75

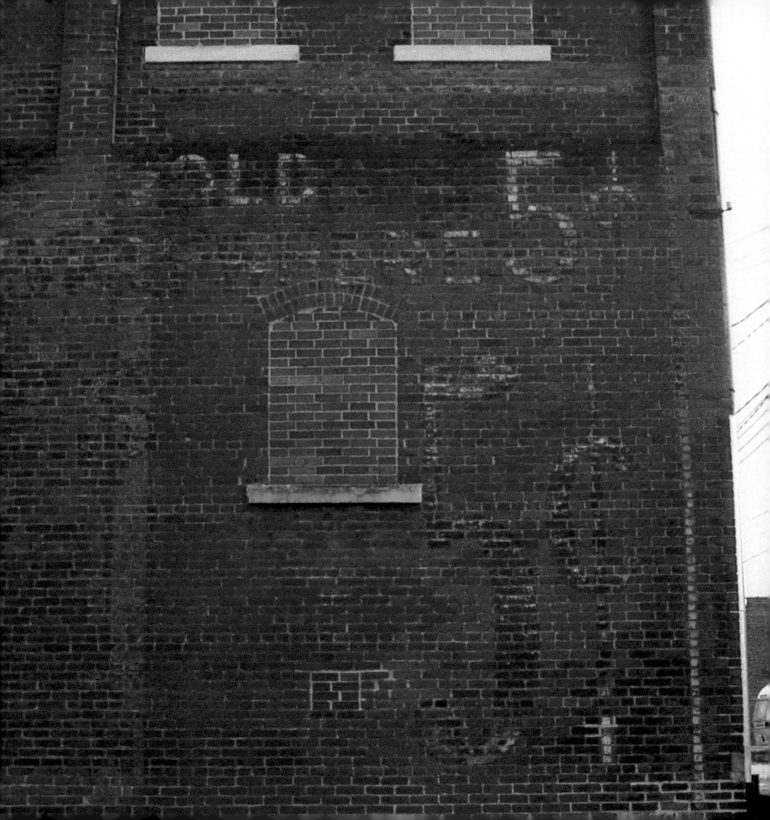

THERE are some signs that can be classified as true ghost signs because of the faint lettering that can be deciphered. Often they can be read more easily after a rain when the background becomes darker, making the images gradually "appear" like apparitions. The white lead paint that was used in most cases is responsible for the ghostly effects because the material was weather resistant.

SPECTERS
OF THE PAST

A portion of a coke sign, "5 cents," fades into the brick, making it barely visible. Jonesboro (Craighead County). *1992*

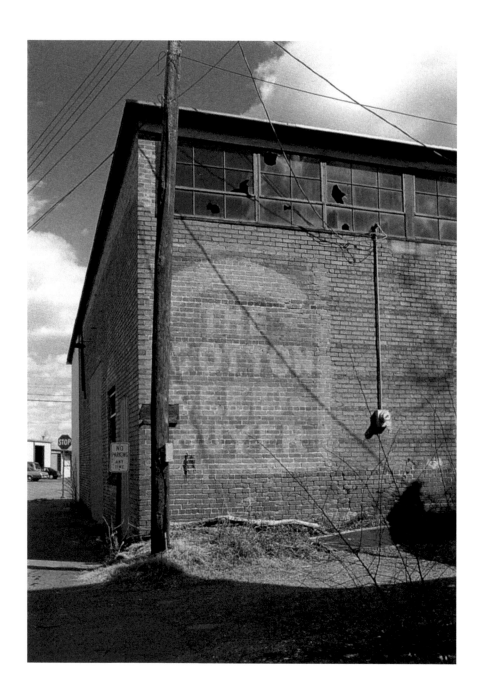

A ghost sign found on the back of an old warehouse building in downtown Conway (Faulkner County) indicates the type of business it once housed. *1991*

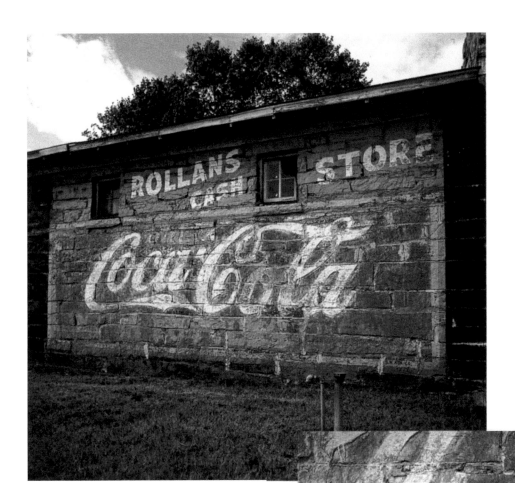

A close-up of a Coca-Cola sign declares the date, February 2, 1952, and the name of the advertising company. It was located on the side of an old gas station building on Highway 22 in New Blaine (Logan County). This sign still exists, but has been repainted and the date is no longer visible. *1991*

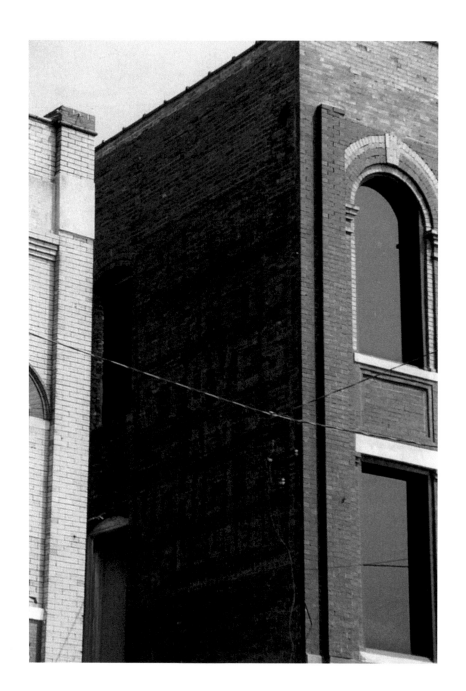

"Carpets, Stoves, and Vehicles—Cash or Credit" graces the upper corner of a building in the 300s block of Main Street in downtown Pine Bluff (Jefferson County). *1993*

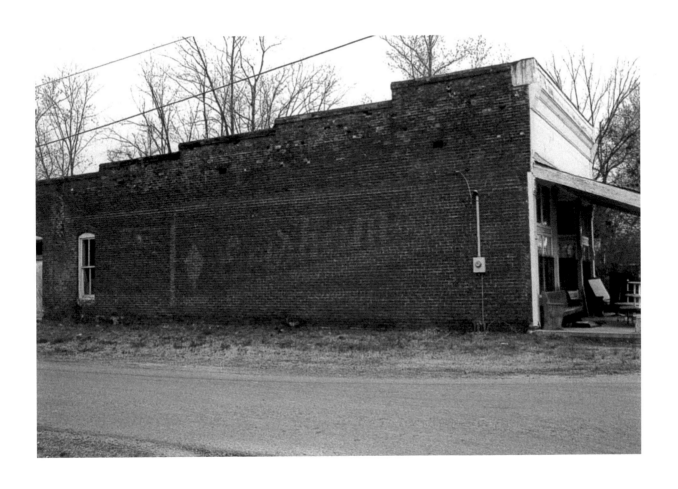

What appears to read as "Grishams" is barely visible on the side
of an old retail building that is located near the railroad in
Old Austin (Lonoke County). *1991*

The Red Drug sign remains on this dilapidated structure along
Highway 335 in Norphlet (Union County). *1990*

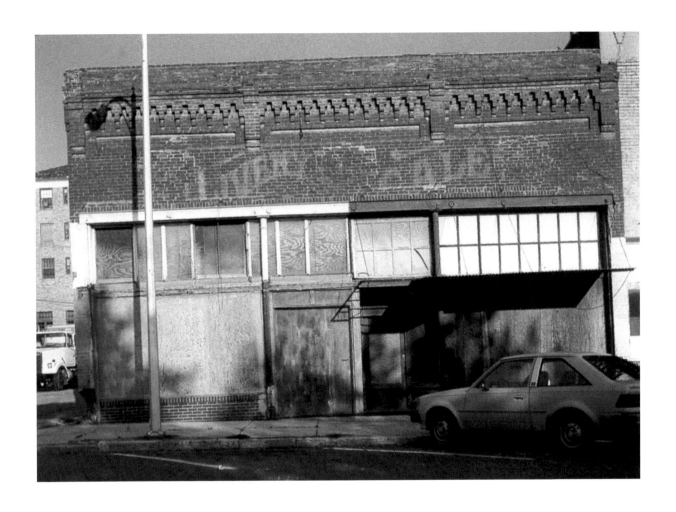

The Livery Sale sign on South First in downtown Rogers (Benton
County) is a reminder of a time when it was common practice
to keep horses and buggies for hire. *1991*

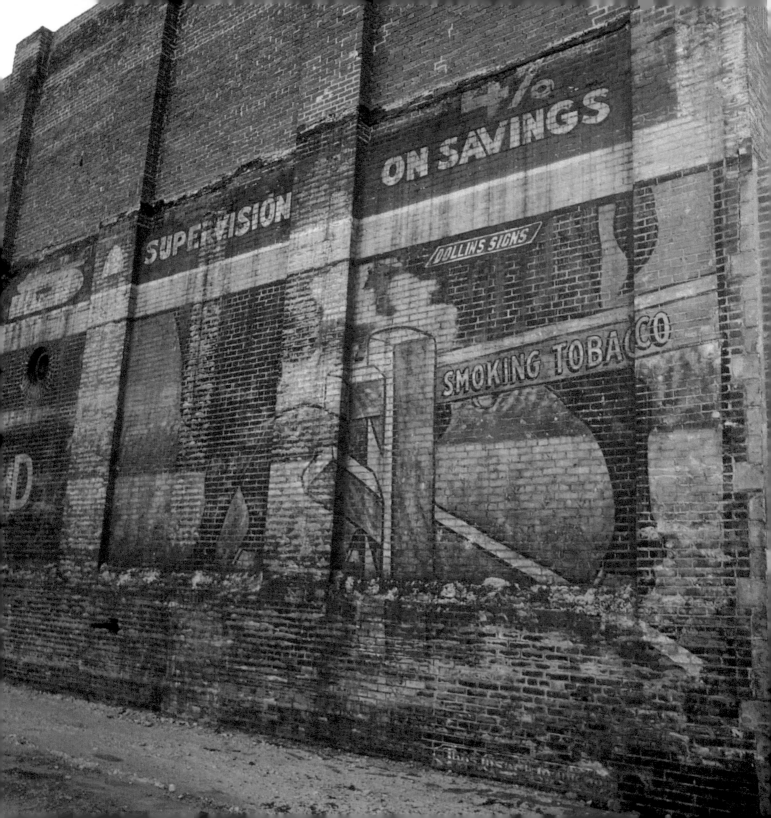

SIGHTINGS

DISCOVERIES of old wall signs occur when an adjacent building burns or is razed and reveals what is left of a "forgotten" advertisement. Other sightings are brought to light when stucco cracks and falls off, exposing a sign painted on the original brick.

A circa 1910 Bull Durham sign and a 1920s bank sign on Union Street in Jonesboro (Craighead County). *1992*

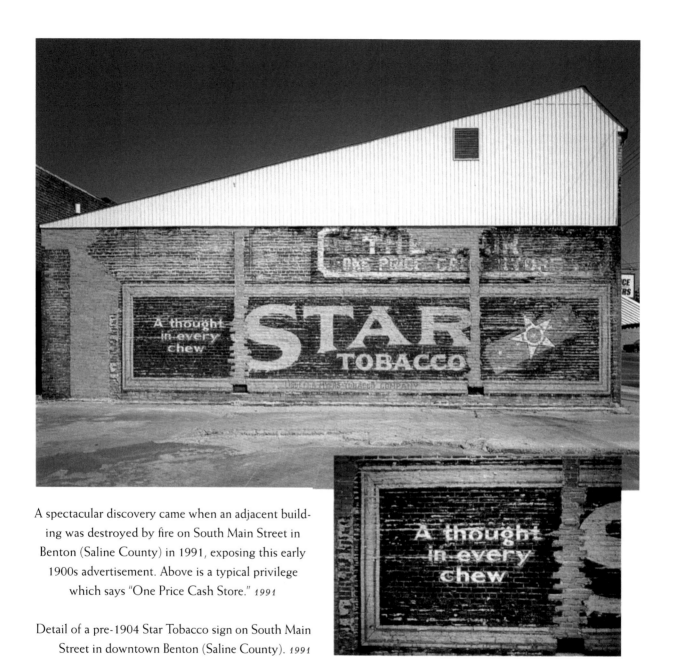

A spectacular discovery came when an adjacent build-
ing was destroyed by fire on South Main Street in
Benton (Saline County) in 1991, exposing this early
1900s advertisement. Above is a typical privilege
which says "One Price Cash Store." *1991*

Detail of a pre-1904 Star Tobacco sign on South Main
Street in downtown Benton (Saline County). *1991*

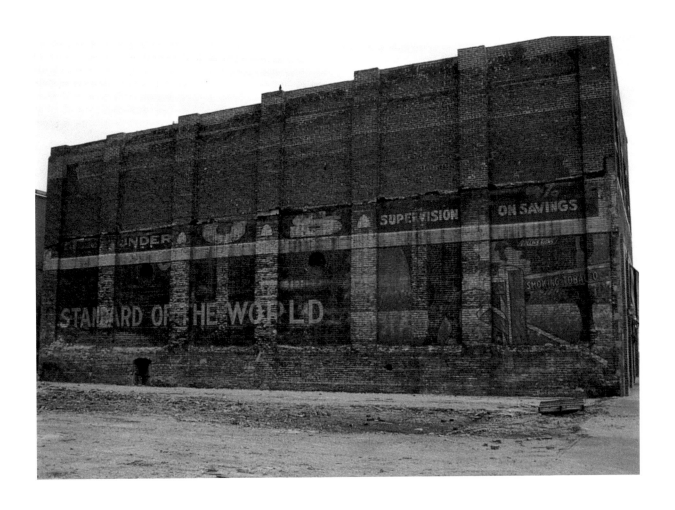

Portions of a circa 1910 Bull Durham sign and a 1920s bank sign were
exposed on this side wall on Union Street in downtown Jonesboro
(Craighead County) when the adjacent building was razed in 1992.
Note the signature of J. J. Dollins, the painter of the bank sign. *1992*

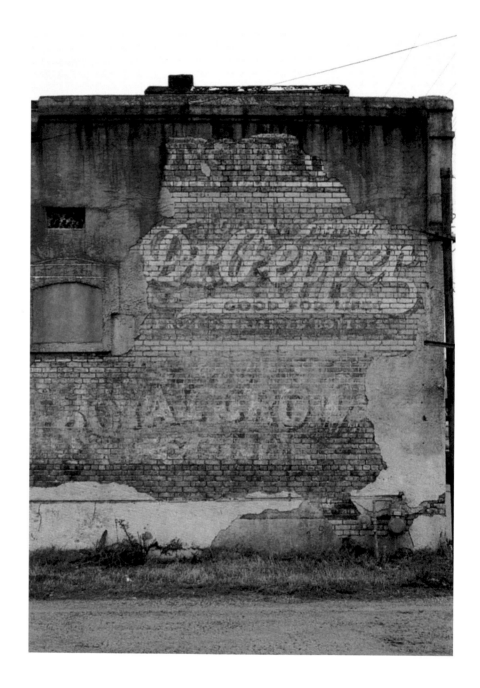

Stucco applied to the brick in an attempt to change the building's appearance has fallen off in places to reveal early Dr Pepper and Royal Crown Cola signs in Eudora (Chicot County). *1991*

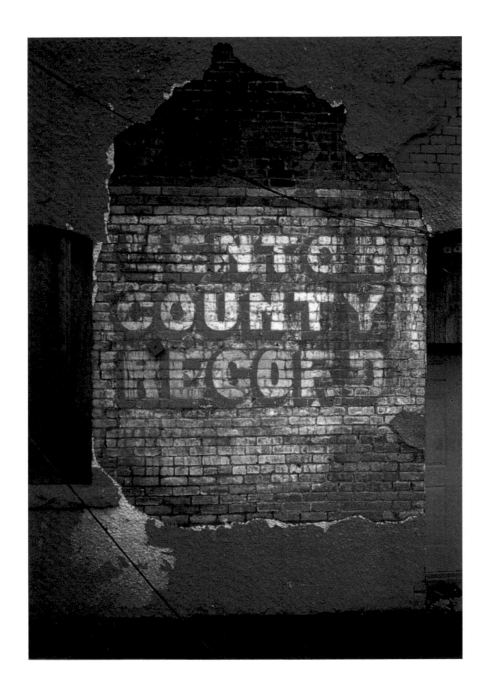

A wall sign for the *Benton County Record* newspaper peeks through the stucco covering
on this building in Bentonville (Benton County). *1992*

Ghost of a Chance

THE prominence of the wall sign began to decline in the 1950s with the emergence of television. The establishment of city ordinances preventing new wall signs on downtown buildings also contributed to their decline. Sign painters could no longer "make deals for walls" and had to turn to other types of sign painting to make a living.

Some Arkansas communities enact local preservation ordinances that can help to preserve and protect historic signs. They seem to sense the interest these special signs generate and use them as backdrops to enhance an otherwise mundane environment.

Some companies like Coca-Cola repainted and maintained their signs on a regular basis as part of company policy. Reconstructions of old Coke signs are common. The Coca-Cola company has an extensive archive in Atlanta, Georgia, where original specifications can be obtained. If crafted by a skilled sign painter, they can be true restorations, not conjectured versions. However, the purpose of this book is to show these images in their original form as part of a building's historic fabric.

The true preservation of ghost signs is through the photographic medium, as they are continually changing as time passes. The essence of this lost art form must be captured before it is gone.

This old ad for Coca-Cola was located in an alley in Malvern (Hot Spring County). *1991*

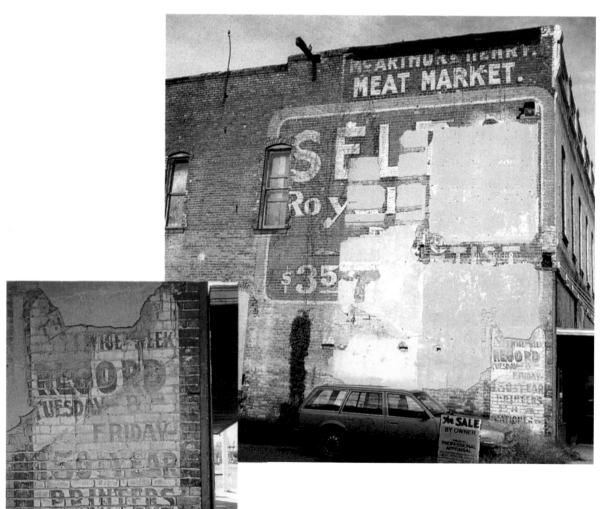

The remaining plaster from the adjoining wall of the old Ritz Theater in downtown Russellville (Pope County) surrounds an advertisement for a semi-weekly paper that ran from 1909 until 1918. It is a portion of a larger sign that has been uncovered and preserved. *1991*

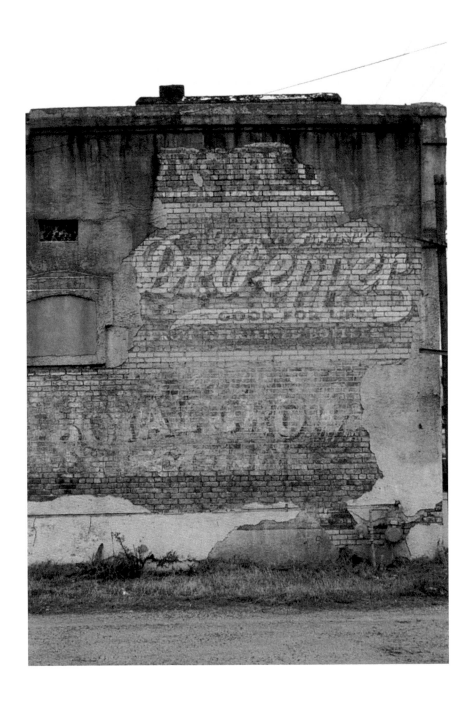

When uncovered, a Selz
Royal Blue advertisement
was found and left in its
original form on West
Main Street in downtown
Russellville (Pope County).
Note the privilege sign
painted above. *1996*

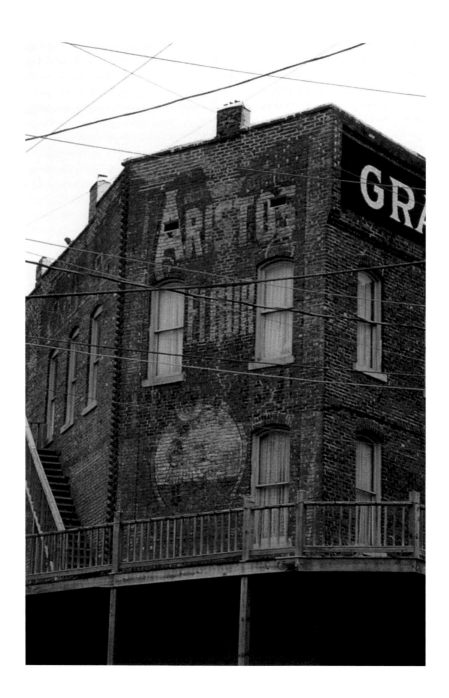

The Aristos Flour sign in downtown Eureka Springs (Carroll County) has been allowed to remain on the face of a five-sided building that was once a stagecoach stop. *1992*

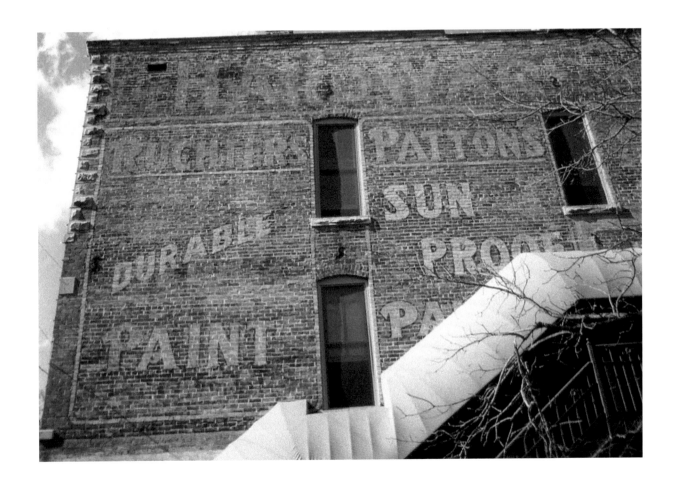

These advertisements from an old paint company survive on a wall of
the Wadsworth Building in Eureka Springs (Carroll County). *1992*

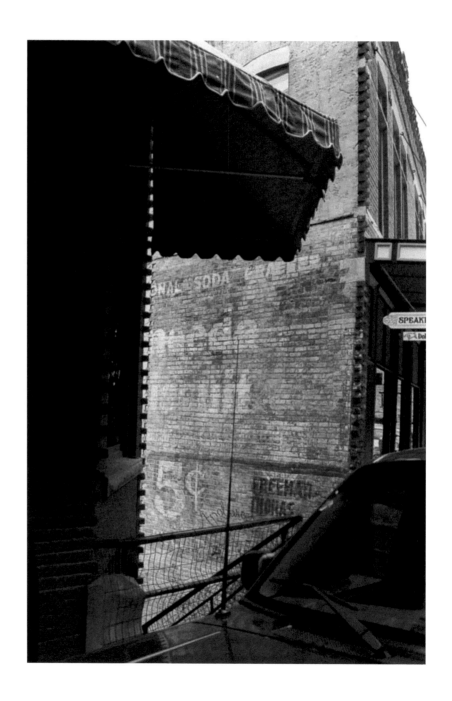

A portion of a Uneeda Biscuit sign can still be seen in downtown Eureka Springs (Carroll County) because the owner painted around it during renovation. *1992*

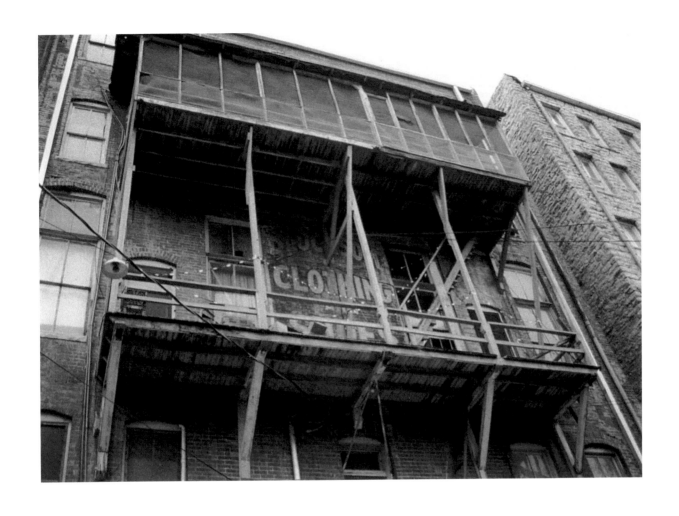

Another protected sign in Eureka Springs (Carroll County)
with the well-known Blocksom name. *1992*

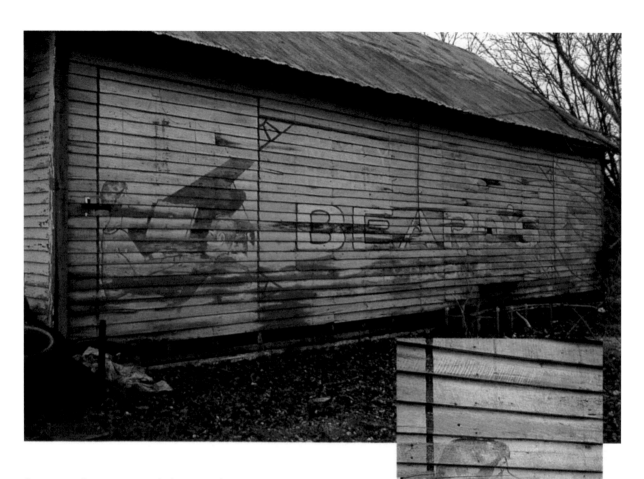

In an era when pianos and phonographs were among the principal sources of home entertainment, Mr. Beard's slogan became, "Make Your Home a Place of Happiness With Music." In the early 1990s, a portion of these words could still be seen on this early 1920s sign on Highway 49 in Halliday (Greene County). *1991*

A close-up showing damage to this sign done a year later. *1992*

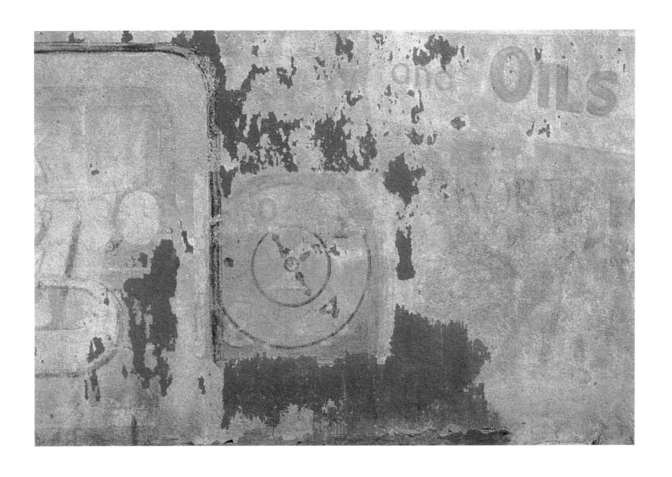

Part of a 1920s-early 1930s Dr Pepper clock logo is still
visible on the side of this structure on Highway 24
in Nashville (Howard County). *1991*

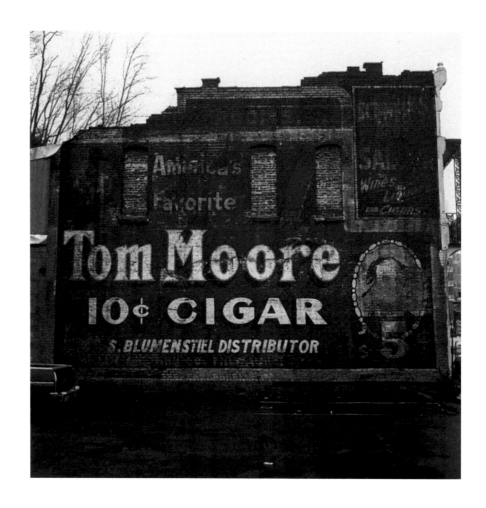

A building burned a few years ago in Hot Springs (Garland County) and
exposed this early cigar sign, which, thanks to their locally ordinanced
historic district, was allowed to retain its original form. *1990*

The stucco that was gradually removed by the owner on an old bail bonds building in downtown Little Rock (Pulaski County) reveals signs that may date to the time when it housed a meat market and an upstairs hotel. *1992*

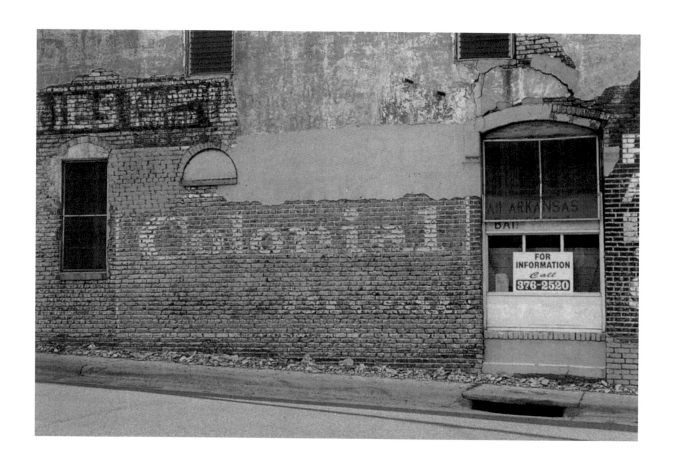

Further stucco removal exposed more signs on the same building. *1993*

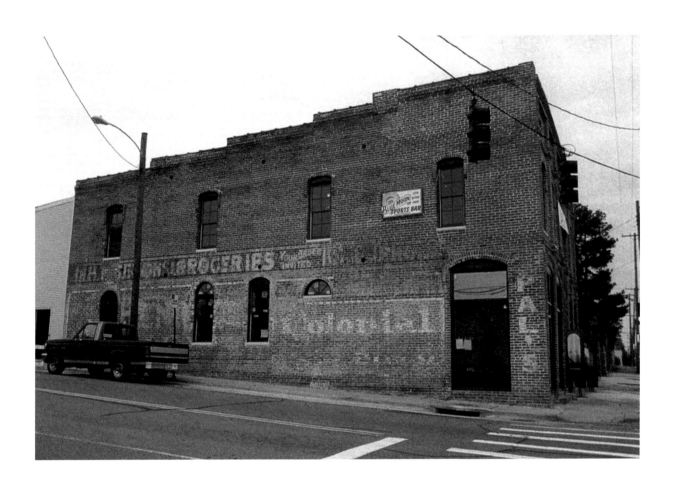

Today, the signs have been retained as part of
the building's historic integrity. *1996*

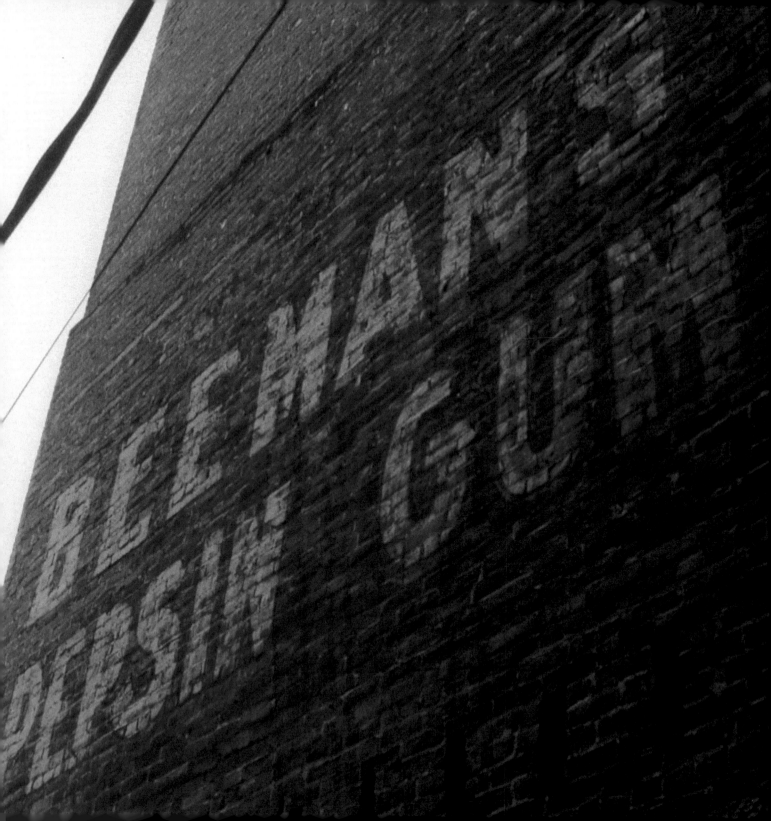

In Closing...

MUCH of what these signs depict is long gone. They now serve as visual biographies, revealing important clues to the past commercial life of any given city or town. It is best summed up in this excerpt from an article by Michael J. Auer of the National Park Service entitled "The Preservation of Historic Signs":

> Signs often become so important to a community that they are valued long after their role as commercial markers has ceased. They become landmarks, loved because they have been visible at certain street corners—or from many vantage points across the city—for a long time. Such signs are valued for their familiarity, their beauty, their size, or even their grotesqueness. In these cases, signs transcend their conventional role as vehicles of information, as identifiers of something else. When signs reach this stage, they accumulate rich layers of meaning. They no longer merely advertise, they are valued in and of themselves. They become icons.

A Beeman's Pepsin Gum sign is found on a wall in Eureka Springs (Carroll County). *1992*

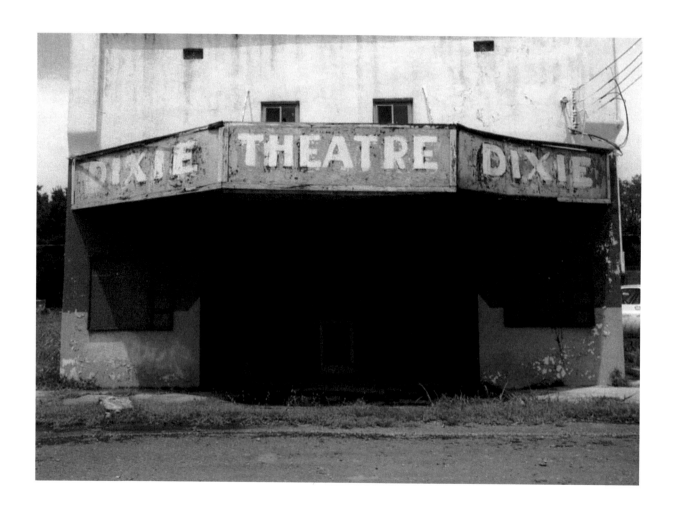

The Dixie Theater still beckons viewers in Mansfield
(Sebastian County). *1994*

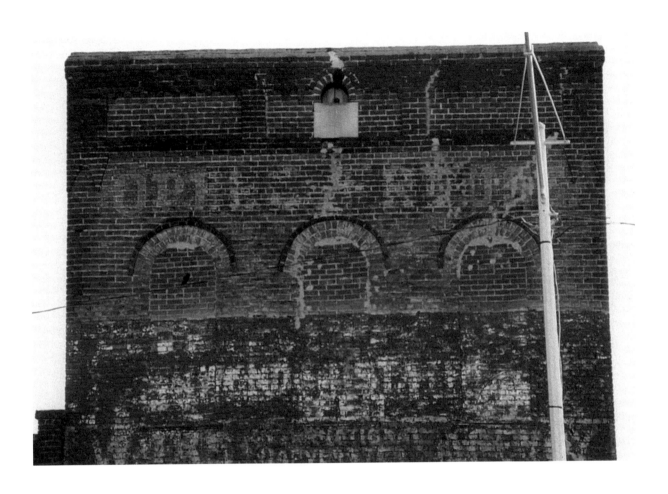

In Wynne (Cross County), this building was an opera house in the late 1800s until 1903 when it became a courthouse for a few years. The lettering depicting the words "opera" and "house" can still be seen. *1992*

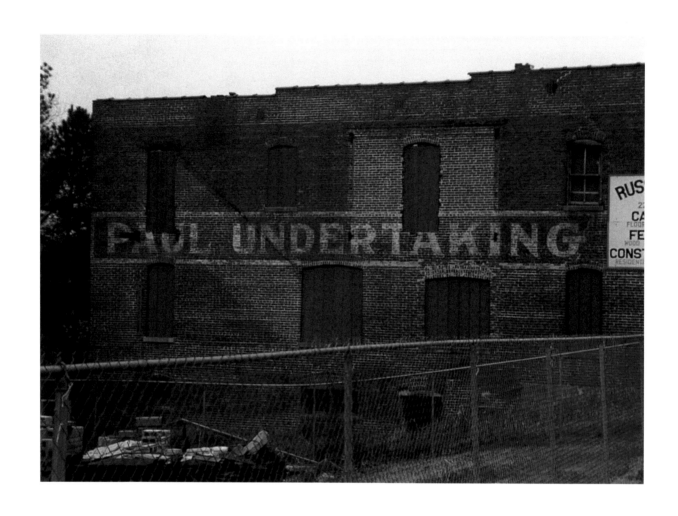

Mr. William Paul, an early undertaker in McGehee (Desha County),
died over forty-five years ago, but the sign telling of his business
that thrived during the 1920s and '30s still remains on
the downtown square. *1991*

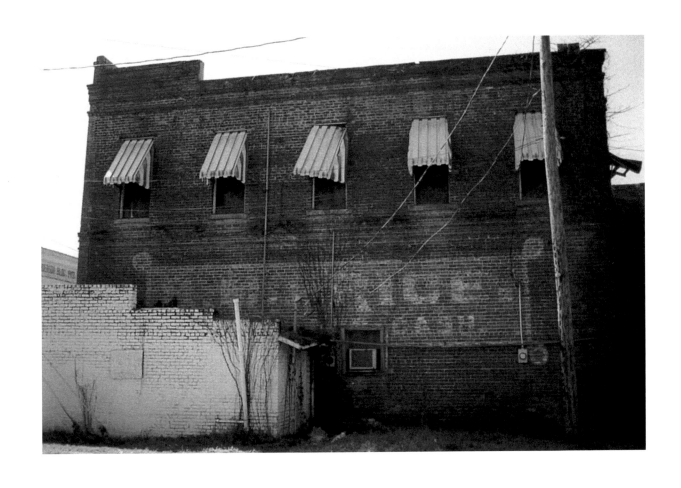

This building facing a railroad in Ashdown (Little River County)
housed a business that took credit along with cash. *1992*

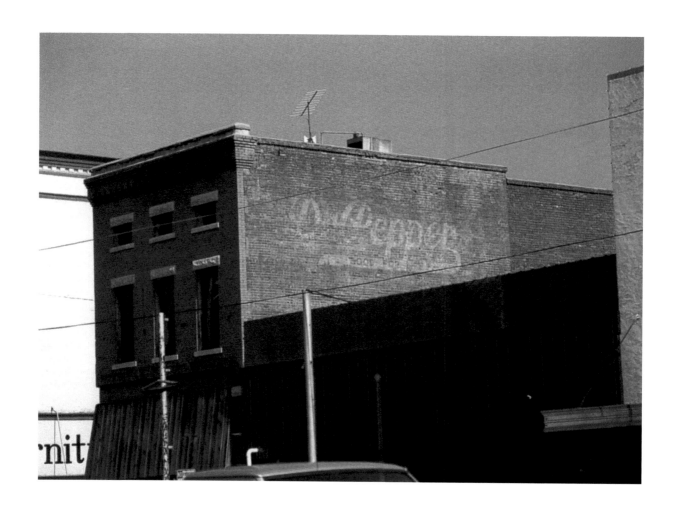

The faint lettering of this true ghost sign of a 1930s Dr Pepper logo
is on Garrison Avenue in Fort Smith (Sebastian County). *1990*

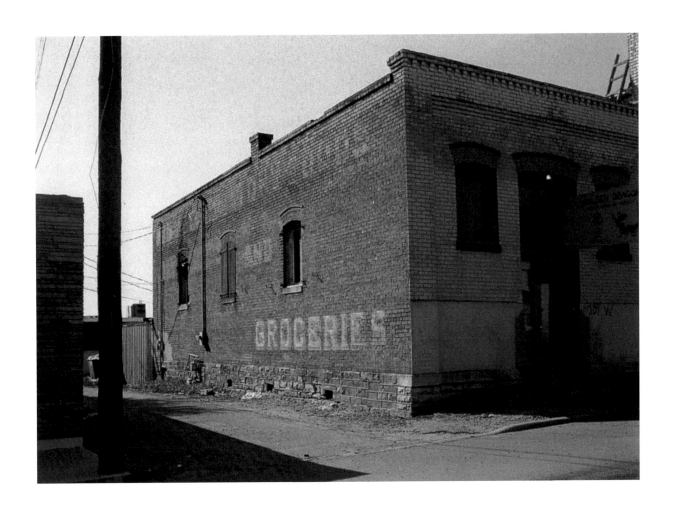

Ozark alleyway (Franklin County). *1990*

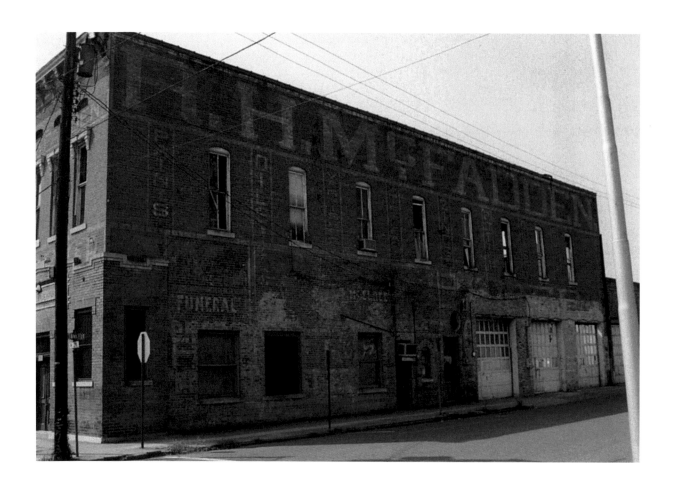

Buildings can house many businesses in their time as these signs
reveal in downtown Pine Bluff (Jefferson County). *1993*

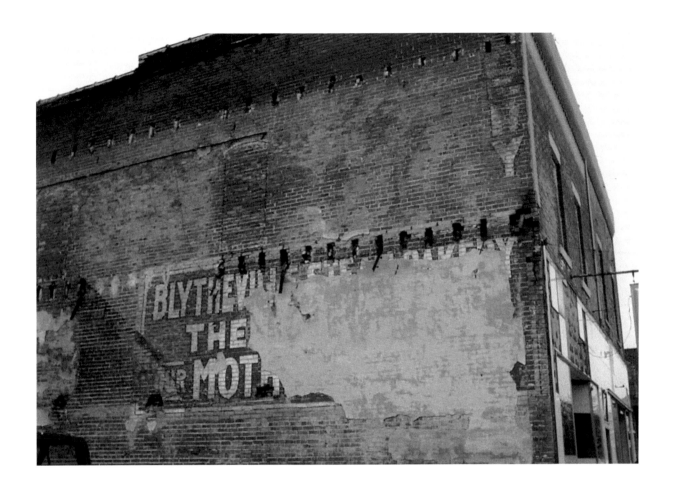

An exposed sign reveals an early 1900s sign that reads,"Blytheville
Steam Bakery, The Home of Our Mother's Bread." According to
records, it was one of the largest bakeries in the area which sold its
own brand of bread. Blytheville (Mississippi County). *1990*

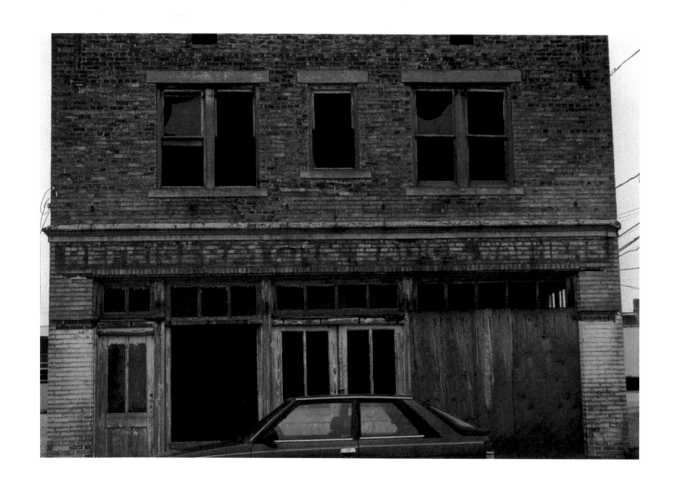

The remnants of an appliance store. Piggott (Clay County). *1992*